IMAGES
of America

PHILADELPHIA'S
OLD SOUTHWARK
DISTRICT

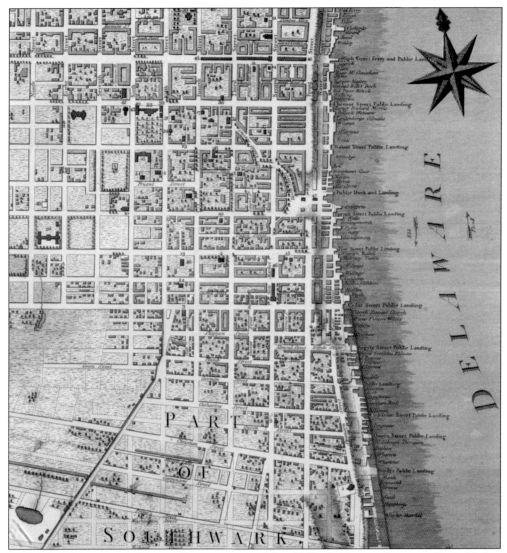

ELEGANT PLAN OF THE CITY OF PHILADELPHIA. John Hill's 1796 map illustrates Philadelphia and its adjacent suburbs. This detail focuses on Southwark and the neighboring city blocks that formed William Penn's "green country town." Southwark's northern boundary can be traced by locating the Cedar Street Public Landing. Cedar Street later became known as South Street in 1853. The southernmost feature on the map is Federal Street Public Landing. In a few short years following this map's publication, the landing would become home to the first US Navy shipyard. (Courtesy of the Historical Society of Pennsylvania.)

ON THE COVER: PUBLICKER COOPERAGE CO. Harry Publicker stands with representatives of the Publicker Cooperage Co. at the Tasker Street Wharf. Publicker's tight cooperage plant opened in the early 1900s at this location. Advertising "the highest prices for oils, tars, glucose, whiskey and vinegar barrels," the company dealt in secondhand and newly manufactured barrels. After suffering a total loss by fire in the summer of 1907, Publicker returned to business until it was sold to the Southwark Cooperage Co. in 1915. Harry subsequently focused his efforts on his new distillery, Publicker Industries. (Courtesy of Clifford B. Cohn.)

IMAGES
of America

PHILADELPHIA'S
OLD SOUTHWARK
DISTRICT

Heather Gibson Moqtaderi
and Mehron Moqtaderi

ARCADIA
PUBLISHING

Published by Arcadia Publishing
Charleston, South Carolina

Printed in the United States of America

Library of Congress Control Number: 2013952345

For all general information, please contact Arcadia Publishing:
Telephone 843-853-2070
Fax 843-853-0044
E-mail sales@arcadiapublishing.com
For customer service and orders:
Toll-Free 1-888-313-2665

Visit us on the Internet at www.arcadiapublishing.com

We dedicate this book to our daughter Leila and all the Southwark children of yesterday, today, and tomorrow.

CONTENTS

ACKNOWLEDGMENTS

It was our great fortune and pleasure to network with the fine group of individuals and institutions who contributed to this project. Our image search was publicized through the Queen Village Neighbors Association, Pennsport Civic Association, Dickinson Square West Civic Association, Friends of Manton Street Park and Community Garden, Southwark Historical Society, and Old Images of Philadelphia. We offer special thanks to those individuals who took time to meet with us and share their memories and resources: Ed Welsh, Trudy Smith, Elaine Righter, Susan McAninley, Ed Kirlin, Jim and Elizabeth Aros, and Maria Oxenford Hicks. We appreciate the specialized advice offered by experts on their respective subjects: Joel Spivak for his knowledge of transportation, trolleys, and the Little Shul; John Grady of the Independence Seaport Museum; Joseph-James Ahern for his expertise on all things Navy Yard; Michele Palmer for her images and information on Fabric Row; and Butch Sigler Johnston for sharing his extensive Publicker Industries archive. We thank the archival resources offered by these institutions: Special Collections Research Center, Temple University Libraries, Philadelphia, Pennsylvania, with special thanks to Josue L. Hurtado; PhillyHistory.org, a project of the Philadelphia Department of Records; Historical Society of Pennsylvania, with special thanks to Sara A. Borden and Hillary S. Kativa; Free Library of Philadelphia; the Library Company of Philadelphia; Independence Seaport Museum, with special thanks to former archives director Megan Good; and the Philadelphia Archdiocesan Historical Research Center, with special thanks to Shawn Weldon. Jane Gibson and Susan Moqtaderi served as careful and thoughtful proofreaders, and we are thankful, as always, for their time and support. We would also like to offer our sincere gratitude to Abby Walker, acquisitions editor at Arcadia Publishing, for her encouragement and guidance throughout the publishing process.

INTRODUCTION

It has been generations since the term Southwark has been commonly used to refer to the neighborhoods southeast of Philadelphia's center city. Today, we know them as Queen Village, Pennsport, Dickinson Square West, and East Passyunk. It was 160 years ago that these neighborhoods were consolidated into the city of Philadelphia. Previously, Southwark existed as a district of Philadelphia County, Pennsylvania, just outside the city limits. In this book, we are interested in revisiting the streets of old Southwark. Within these pages, you will discover nearly 200 vintage photographs of residents, row houses, churches, synagogues, restaurants, shops, factories, and much more. The images of these people and places offer a lens into a unique and culturally rich past.

As relative newcomers to Southwark (one of us having lived here 13 years, the other only a few), we took on this publication project as a way to learn more about the area and celebrate its past. We were aware of the highly visible historic sites, such as Gloria Dei Church and the Sparks Shot Tower. We had a hunch that there was much more, but we were hardly prepared for the overwhelming amount of historical interest we discovered. We began with library and archival research, using the rich resources available to historians in Philadelphia. We were also impressed by the body of articles published by the Southwark Historical Society, Queen Village Neighbor's Association, and the Historical Society of Pennsylvania. This published research was an essential component in our process of interpreting the historic photographs in this book.

We found a second step equally as important as the published research—oral history. By speaking with longtime residents (many of whom are second- and third-generation Southwarkers) and business owners, we gained a sense of the old neighborhood's sights, sounds, smells, and overall way of life. Those interviews also brought out family photographs not available through public archives. This introduction reflects both aspects of our research process. We begin here with a more formal history of Southwark and then move on to some of the personal recollections shared by longtime Southwarkers.

The settlement of Southwark by Europeans predates the founding of the city of Philadelphia. Before European settlement, the Native American Lenni Lenape (also known as the Delaware) tribe inhabited the area. They called the location Wicaco, meaning "peaceful place." The Lenni Lenape lived as an agriculturally based society, farming maize, beans, and squash. The tribe also hunted the land of Wicaco and fished the waters of the Delaware River. When the Swedes established the colony of New Sweden in 1638, they set up a trading fort in the area of the Lenni Lenape's Wicaco. The Swedes retained the area's name, although alternate spellings developed, including Weccacoe.

Although the colony of New Sweden was relatively short-lived, the Swedes who settled Wicaco continued to live there. When William Penn's settlement took hold in 1681, the Swedes were joined by English, Irish, Scottish, Welsh, and Germanic immigrants, in addition to enslaved people from the African continent. The English settlers referred to the Wicaco area as Southwark. This name was based on the community's location to the south of Philadelphia, just as London's southern

neighbor is called Southwark. In 1762, the Commonwealth of Pennsylvania established the District of Southwark to be an independent municipality outside of the city limits. The district's municipal headquarters at Second and Christian Streets (no longer standing) is pictured in this book.

In 1854, Southwark was incorporated into the city of Philadelphia by way of the Consolidation Act, which extended the city limits from 2 square miles to nearly 130. Residents retained the old name of Southwark for many years, of course, due to the long history of its use. It was not until the third quarter of the 20th century that the modern neighborhood names began to take precedence.

Architecture serves as a tangible link to Southwark's past. Southwark oral histories revolve around the architecture that South Philadelphians call home—the row house. Most old row houses in Southwark are two or three stories tall and faced with brick. The houses commonly have white marble steps that were used for sitting almost as much as stepping. Longtime residents recall the intense weekly cleanings of the marble. On Saturday mornings, mothers would enlist their children to help scrub the steps.

Those marble front steps played a significant role in the lives of Southwark dwellers throughout the neighborhood's history. Those who were children in the 1950s remember long hours spent playing with toys on the front steps. Parents often photographed their children posed on the steps when dressed for special occasions like Easter or holding a flag on the Fourth of July. Parents themselves spent evenings "sitting out" on the front steps or nearby in folding chairs. It was a way to get fresh air and socialize with neighbors passing by.

The streets lined with row houses were punctuated by independent mom-and-pop businesses. In the days before the major chain stores dominated the marketplace, you could buy pretty much anything you needed right in Southwark. Butchers, pharmacists, produce vendors, and other specialized shops served local residents. Seventh Street below Tasker was a major shopping district for everything from new school clothes to the evening's dinner. Fourth Street below South was also known for its market, which in the early days started as a pushcart market. Second Street was likewise lined with corner stores, although only a few retain their original decorative carved moldings and storefront windows.

Within these pages, we illustrate the row houses and little shops of earlier days, along with more monumental structures. Churches, synagogues, schools, and firehouses all make their distinctive marks on the cityscape. In recent decades, many of these structures have been repurposed. Christian churches became synagogues, which sometimes became churches again or even Buddhist temples. School buildings and firehouses metamorphosed into condominiums. The repurposing of old buildings creates a richly layered history that enhances the old Southwark District's historical resonance. We hope to illuminate the past lives of these city streets to enhance the public's understanding and appreciation of this lively historic community.

One

HIGHLIGHTS OF
EARLY SOUTHWARK

Southwark enjoys the distinction of being one of the Delaware Valley's earliest settlements. Over the course of three centuries, Southwark has been home to diverse communities of immigrants who settled its narrow, slanted, and in some cases, mazelike streets. The current area is a mixture of old architectural structures and new development. Many of Southwark's monuments to the past are hidden in plain view or simply no longer extant. An event like the Meschianza of 1788—the fete thrown in honor of British general William Howe—can only be imagined through drawings and the words of those in attendance. Over 400 guests attended the festivities, which began with a regatta and procession along the Delaware River and culminated at Walnut Grove, the country estate of merchant Joseph Wharton, located at Fifth Street and Washington Avenue, fronting the Delaware River. The bash, featuring a mock knight's tournament, dinner, and fireworks, stretched until four in the morning.

This first chapter illustrates some highlights from Southwark's history as a settlement and significant port. Of particular interest is America's first Navy Yard, which was located at Federal Street on the Delaware River. Preparations to move the yard began in 1873, and by January 1, 1876, the Navy Yard was officially relocated to League Island.

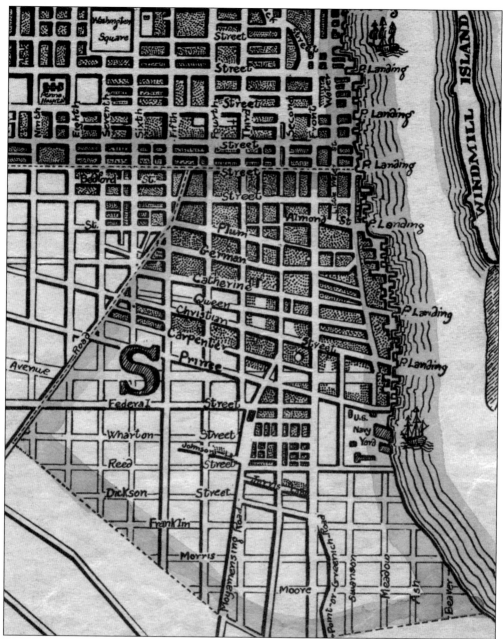

PHILADELPHIA, 1824. Thomas Drayton's 1824 Philadelphia map illustrates the city's development at the first quarter of the 19th century. The wedge-shaped district of Southwark, designated by the letter S, lies to the southeast, along the Delaware River. The district's angled streets stand in contrast to the more orderly grid of streets above. The Southwark District is bounded by Passyunk Avenue on the west and the Delaware River on the east. The northern boundary lies along South Street, from the river to the steeply angled Passyunk Road. (Courtesy of the Historical Society of Pennsylvania.)

Pl. XLIX

For the BENEFIT of the WIDOWS and ORPHANS
of the ARMY.

On Monday

Next. the *Nineteenth* Inftant,

Will be Reprefented, at the THEATRE in Southwark,

A COMEDY, CALLED

NO ONE'S ENEMY
BUT HIS OWN,

AND

The Deuce is in Him.

The CHARACTERS by the OFFICERS of the ARMY and NAVY.

Admittance to the Boxes and Pit. A DOLLAR each:
Gallery, HALF A DOLLAR.

TICKETS to be had of the Printer; at the Coffee-houfe;
at the Pennfylvania Farmer, New-Market; of Mr. Smith,
at his Office in Front-ftreet, below the Drawbridge, and
a few Doors below Peter Suter, Hatter at Mr. John
Richmond's in Front-ftreet, between Chefnut and Wal-
nut-ftreets, and at the Turk's Head in Water-ftreet,
between Race and Vine ftreets.

As there is a fufficient Number of Tickets to be given
out, to admit as many as the Houfe will hold, no Money
can, on any Account, be taken at the Door.

The Doors to be open at Six o'Clock, and the Play to
begin precifely at Seven.

PHILADELPHIA, PRINTED BY JAMES HUMPHREYS, JUNE.
Theatricals of the British Army in Philadelphia

NO ONE'S ENEMY BUT HIS OWN, SOUTHWARK THEATRE, 1788. Philadelphia's first permanent theater building was constructed at the corner of Cedar and Apollo Streets (now South and Leithgow, respectively) in Southwark. Built in 1766, the Southwark Theatre was erected on the northern border between the city of Philadelphia and district of Southwark. The theater lay on the south side of Cedar Street, outside of Philadelphia's jurisdiction and its more conservative regulations regarding entertainment. The theater operated successfully through much of the 18th century as Philadelphia's preeminent theatrical venue. It remained in service in the early 1800s until the building burned down in 1823. During the British occupation of Philadelphia in 1788, officers of the British army took over the Southwark Theatre. The admission fee of a dollar (or half dollar for standing room in the gallery) was donated to the widows and orphans of the British army. (Image accessed through Early American Imprints.)

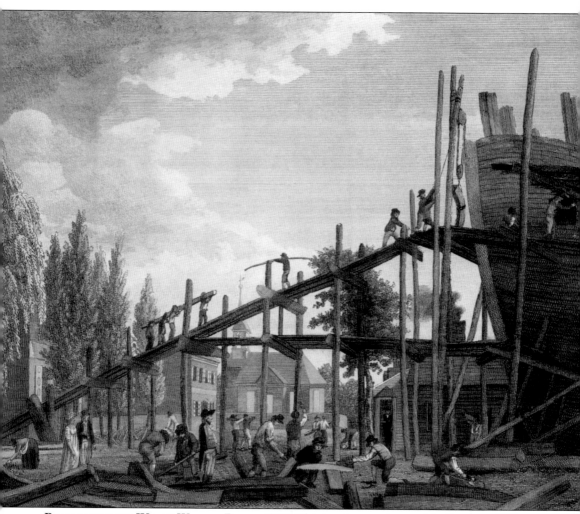

PREPARATION FOR WAR BY WILLIAM BIRCH, 1799. This iconic scene by notable illustrator William Birch depicts the construction of the frigate *Philadelphia* at Humphreys & Wharton Shipyard. Located at Front and Federal Streets near the Delaware River, this became America's first Navy shipyard in 1801. Joshua Humphreys was named naval constructor in 1794. In this role, he designed the first six frigates of the new US Navy, including the *Constitution*, pictured undergoing renovation on the following page. In Birch's illustration, Gloria Dei (Old Swedes' Church) is visible behind the shipyard. It has been suggested that the man standing in the center of the scene is Humphreys. (Courtesy of the Library of Congress.)

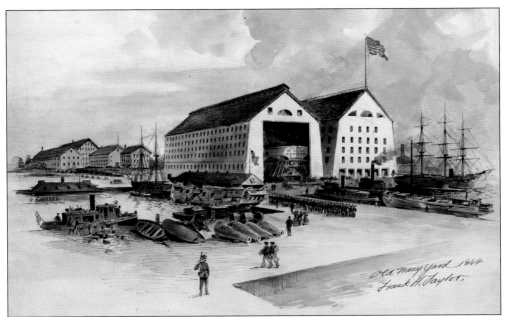

OLD NAVY YARD. Frank H. Taylor's watercolor shows the old federal Navy Yard as it looked in 1864. The Navy Yard's most distinctive feature was its massive twin boathouses. To the left of the boathouses is the receiving ship USS *Princeton*, and a Confederate ironclad schooner-rigged screw steamer is anchored in the shipyard. Among the stockpiles of supplies in the yard are Dahlgren guns. (Courtesy of the Historical Society of Pennsylvania.)

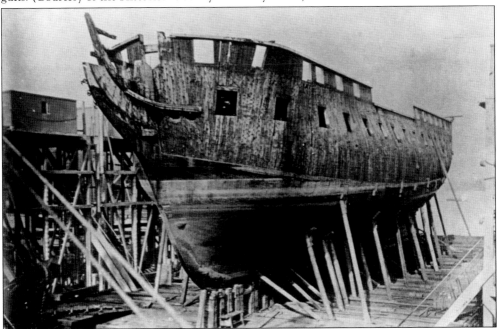

USS CONSTITUTION AT THE OLD NAVY YARD. This c. 1875 photograph of the USS *Constitution* shows the famous ship being re-topped at the old Navy Yard's floating dry dock. Built in Boston in 1797, the *Constitution* remains the oldest commissioned warship still afloat. The USS *Constitution* was the last project taken on at the old Navy Yard. (Courtesy of the Historical Society of Pennsylvania.)

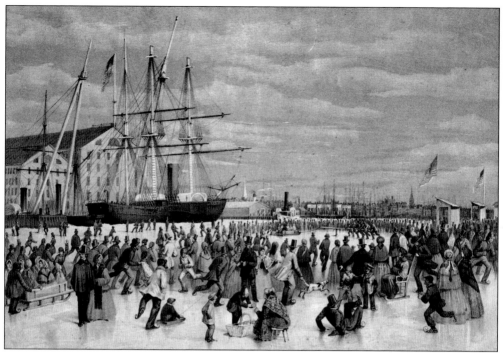

DELAWARE RIVER, 1856. This lithograph by James Fuller Queen was printed as a souvenir of the "coldest winter on record." The Navy shipyard provides a backdrop for this jubilant occasion. Notice the peddler woman selling apples, a woman seated in a chair outfitted with sled blades, a sleigh filled with young ladies, a hound lunging away from its master, and hundreds of skaters. (Courtesy of the Library of Congress.)

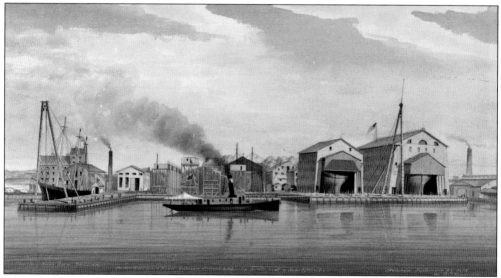

THE OLD US NAVY YARD. David J. Kennedy commemorated the final days of the old Navy Yard in Southwark. Kennedy's handwritten inscription reads, "The Old U.S. Navy Yard Philadelphia, Penn'a. Situate on the Delaware River, bounded by Front, Prime and Wharton Streets, some of the best and most efficient vessels of war in the United States Navy were built here." (Courtesy of the Historical Society of Pennsylvania.)

MESCHIANZA TICKET, 1778.
Prior to his departure from
Philadelphia, British general
William Howe's officers
threw an extravagant fête
in his honor called the
Meschianza, which took
place along the Delaware
River and ended at Joseph
Wharton's estate at Fifth
Street and Washington
Avenue. Maj. John André
organized and designed the
details of the event, from
the location and scenery
to women's costume and
this admittance ticket,
which is reprinted from
Benson J. Lossing's *The
Pictorial Field-Book of the
Revolution*, 1851. The ticket
features Howe's crest and
the motto "Descending I
shine; with added splendor
I rise again." (Courtesy
of Roy Winkelman.)

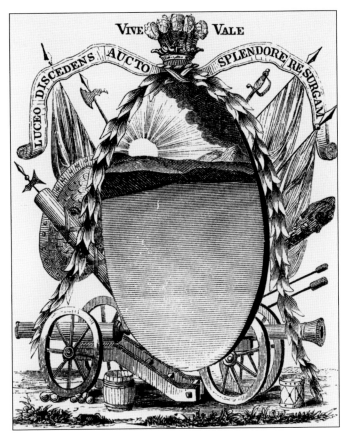

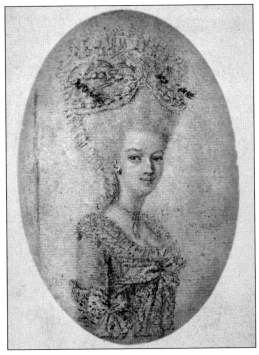

**PEGGY SHIPPEN IN MESCHIANZA
HEADDRESS.** This drawing illustrates
Philadelphia socialite Margaret "Peggy"
Shippen just under a year before she
married Benedict Arnold. Maj. John
André favored the young Shippen and
designed this headdress for her to wear to
the Meschianza ball at Joseph Wharton's
Southwark estate. Festooned with fanciful
ribbons, elaborate headdresses of this sort
would take hours to prepare. Major André
himself sketched this portrait. (Courtesy of
the Historical Society of Pennsylvania.)

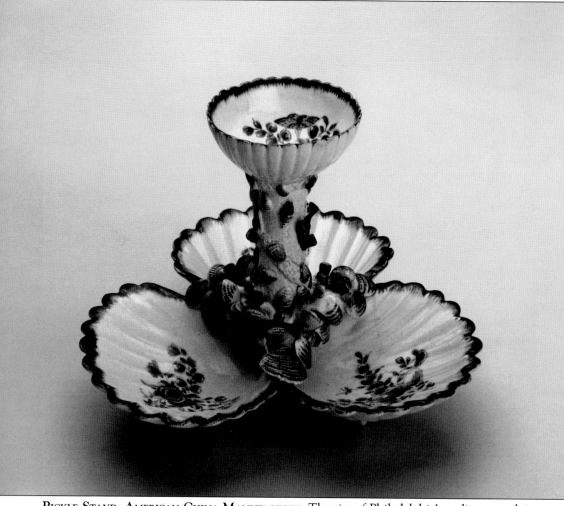

PICKLE STAND, AMERICAN CHINA MANUFACTORY. The site of Philadelphia's earliest porcelain factory lies just below Prime Street (now Washington Avenue) on what was the former aptly named China Street (now Alter Street). The firm was known as Bonnin and Morris after its founders, British-born Gousse Bonnin and Philadelphian George Anthony Morris. The company operated from 1770 to 1772, during which time the Nonimportation Act barred the American colonies from trading with England. Bonnin and Morris responded to the taste of the American colonial elite for English porcelain wares. A pickle stand such as this one was used as a decorative serving dish for pickled fruits and vegetables. While this piece bears resemblance to a pickle stand made by the English Bow factory, there is an interesting distinction: the Bonnin and Morris dish was molded directly from natural scallop shells. (Courtesy of the Metropolitan Museum of Art.)

Two

PIER 53 AND THE WASHINGTON AVENUE IMMIGRATION STATION

The population of Southwark in the 19th century was largely comprised of immigrant communities. In addition to the Swedish and English settlers and their descendants, large numbers of Irish immigrants began to call Southwark home. From 1873 until 1915, thousands of these new residents came through Philadelphia's immigration station each year by ship at the foot of Washington Avenue on the Delaware River. The pier, owned by the Pennsylvania Railroad, was connected to an expansive network of rails leading in all directions through the city and beyond. The Pennsylvania Railroad founded the first a line of steamships to service this station—the American Line, which ran between Philadelphia and Liverpool, England, stopping in Queenstown, Ireland. In the final decades of the 19th century, the American Line carried 20,000 immigrants into Philadelphia each year. The Red Line service, also funded by the Pennsylvania Railroad, ran between Philadelphia and Antwerp, Belgium, providing a direct connection from continental Europe. Later, the Hamburg-American Line brought large numbers of Jewish and Polish immigrants from Russia and Austria-Hungary. Immigration through the Washington Avenue pier peaked in 1913, with over 60,000 immigrants arriving.

This publication coincides with the inauguration of the Pier 53 waterfront park that utilizes the space once occupied by the immigration pier and station. In 2010, a public urban park was established on the land adjacent to the site of Pier 53. Called Washington Avenue Green, the park was executed through the Action Plan for the Central Delaware, a partnership between design group Penn Praxis and a group of neighborhood associations. Washington Avenue Green embraces the trees and plants that have flourished since the pier itself was active. The concrete has been strategically broken to enhance the natural landscape that had developed on its own. In 2013, the city broke ground on an exciting new component to Washington Avenue Green—renovation of Pier 53 itself. The new design will allow visitors to walk out onto Pier 53 and experience the Delaware River.

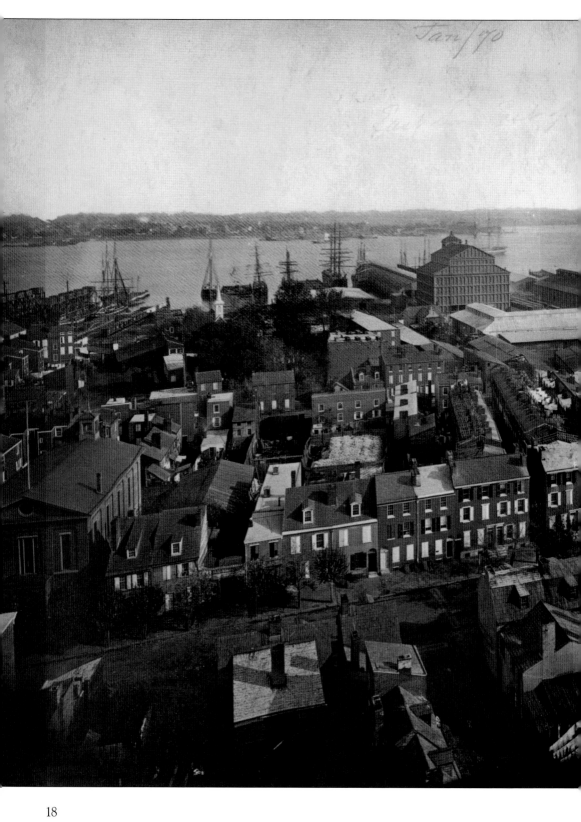

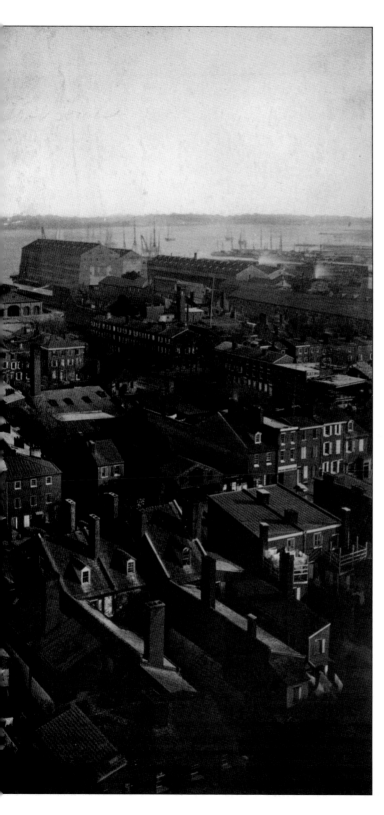

PANORAMA OF PHILADELPHIA: EAST VIEW FROM SHOT TOWER. This panorama was photographed from the top of the Sparks Shot Tower in 1870. The block of buildings on the east side of Front Street in the foreground, including Mariner's Bethel Church in the lower left corner of the image, were demolished for the construction of Interstate 95. Along the riverfront, the tallest building in the center is the Washington Avenue Grain Wharf. To the right is the railroad depot that became the immigration station in 1873. Farther south, the old US Navy Yard complex is visible to the right of the immigration station. (Courtesy of the Bridgeman Art Library and the Philadelphia Free Library.)

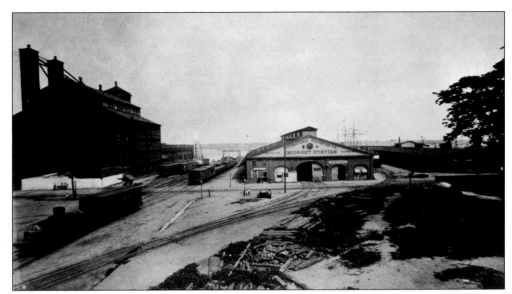

WASHINGTON AVENUE IMMIGRATION STATION. Philadelphia's immigration station was a portal through which nearly one million immigrants passed between 1873 and 1915. Situated at the foot of Washington Avenue on the Delaware River, the station was owned by the Pennsylvania Railroad. This photograph shows the railroad tracks leading directly into the station through the central garage. (Courtesy of the Historical Society of Pennsylvania.)

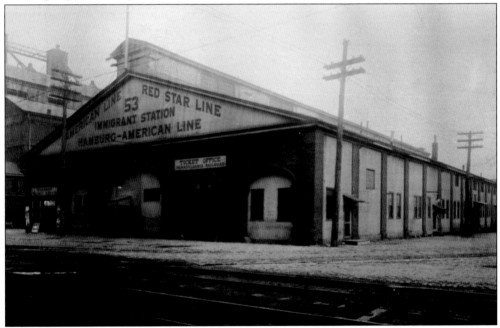

IMMIGRATION STATION ACROSS DELAWARE AVENUE. The railway provided transportation to settlement destinations west of Philadelphia, but some immigrants settled just down the street, in Southwark. The Pennsylvania Railroad used the railway as a marketing strategy for attracting immigrants to Philadelphia's port, boasting, "Philadelphia being 100 miles nearer the West than New York, passengers on this line are assured a shorter and more direct route and lower railway fare." (Courtesy of PhillyHistory.)

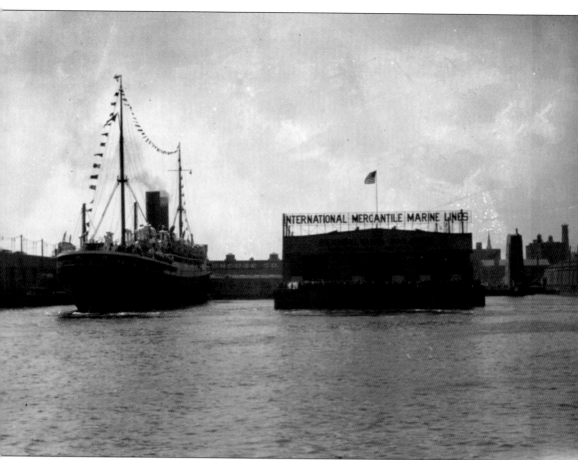

Pier 53, Viewed from the Delaware River. When Philadelphia's immigration station began operating in 1873, it ran the shipping lines of the International Merchant Marine Company. The popular Red Line and American Line transported travelers between the United States and Liverpool, England, with a stop in Queenstown, Ireland. In the late 1800s, the station added the Hamburg-American Line, bringing immigrants from Eastern Europe. Notice the difference in signage between the two photographs on the previous page. In the earlier photograph, the station's lettering reads, "International Navigation Co. Emigrant Station," along with "Red Line" and "American Line." The 20th century image shows the pier number "53" with addition of the Hamburg-American Line. (Courtesy of PhillyHistory.)

THE PENNSYLVANIA RAILROAD

IN THE

GREAT THROUGH MAIL ROUTE OF THE UNITED STATES

BETWEEN

THE ATLANTIC SEA-PORTS

AND ALL THE

WESTERN STATES AND TERRITORIES

View of an Emigrant Train.

The PENNSYLVANIA RAILROAD COMPANY owns or controls six thousand miles of railroad, giving them direct and independent lines to all the great business cities of the United States.

This powerful combination enables the Pennsylvania Railroad to **run long distances without the trouble and annoyance** to passengers of change of cars, making this the **especially favored route for Emigrants and Families emigrating West.**

Steamer Docks and Railroad Depot, Philadelphia.

A Passenger train leaves this Depot **within a few hours after the arrival of each Steamship**, connecting with all stations in the United States and Canada accessible by railroads or steamers, offering to all who desire it the means of saving time, money, and annoyance.

Interior of Steamship Landing, Philadelphia.

The Steamships of the American Line land at docks in Philadelphia directly connected with an **Emigrant Passenger Depot of the Pennsylvania Railroad.**

The Railroad Depot is large, well roofed and lighted, and affords every facility for the landing of Passengers, Baggage, and Freight.

AMERICAN L

[AMERICAN STEAMSHIP CO. OF PHILADELPHI

PENNSYLVANIA, INDIANA, OHIO.

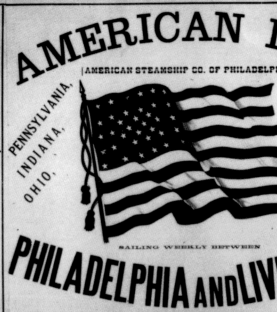

SAILING WEEKLY BETWEEN

PHILADELPHIA AND LIVE

CALLING AT QUEENSTOWN BOT

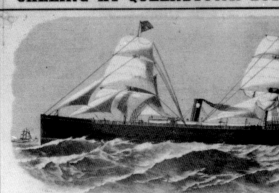

ONE OF THE WELL-KNOWN, FIRST-CLASS, FULL-POWERED, IRON MAIL STR

EVERY THURSDAY FROM PHIL

AND

EVERY WEDNESDAY FROM LI

CARRYING PASSENGERS TO AND FROM

| GREAT BRITAIN, | GERMANY, | N |
| IRELAND. | SWEDEN, | D |

And all other parts of the Continent of Europe, at Rates as low as

PETER WRIGHT & SONS, General Agents. J. H. MILNE

307 Walnut Street, Philadelphia, Pa. *138 L*

22

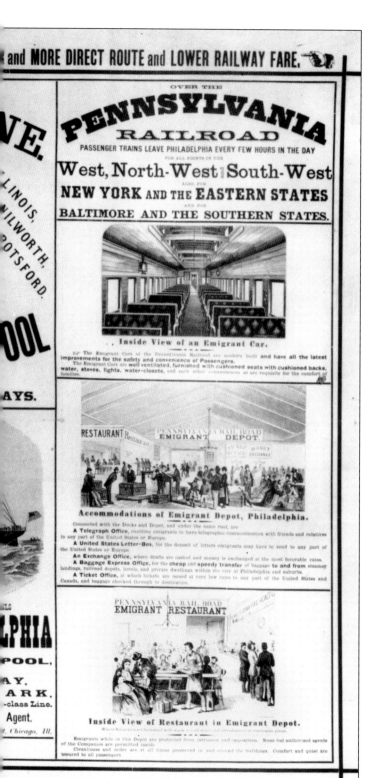

AMERICAN LINE STEAMSHIPS BROADSIDE. This advertisement promotes the American Line's service between Philadelphia and Liverpool. The vignettes illustrate scenes of the immigration station and railway, displaying a full range of services available to the newly arrived immigrants. Among the accommodations offered by the immigration station are a restaurant, telegraph office, and a currency exchange office. (Courtesy of the Independence Seaport Museum.)

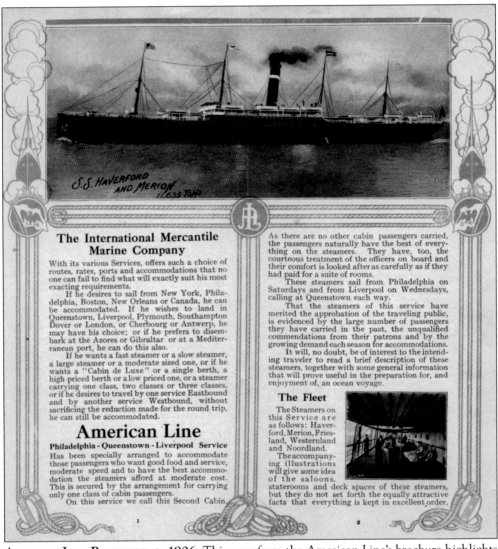

S.S. HAVERFORD
AND MERION
11,635 TONS

The International Mercantile Marine Company

With its various Services, offers such a choice of routes, rates, ports and accommodations that no one can fail to find what will exactly suit his most exacting requirements.

If he desires to sail from New York, Philadelphia, Boston, New Orleans or Canada, he can be accommodated. If he wishes to land in Queenstown, Liverpool, Plymouth, Southampton Dover or London, or Cherbourg or Antwerp, he may have his choice; or if he prefers to disembark at the Azores or Gibraltar or at a Mediterranean port, he can do this also.

If he wants a fast steamer or a slow steamer, a large steamer or a moderate sized one, or if he wants a "Cabin de Luxe" or a single berth, a high priced berth or a low priced one, or a steamer carrying one class, two classes or three classes, or if he desires to travel by one service Eastbound and by another service Westbound, without sacrificing the reduction made for the round trip, he can still be accommodated.

American Line

Philadelphia - Queenstown - Liverpool Service

Has been specially arranged to accommodate those passengers who want good food and service, moderate speed and to have the best accommodation the steamers afford at moderate cost. This is secured by the arrangement for carrying only one class of cabin passengers.

On this service we call this Second Cabin.

As there are no other cabin passengers carried, the passengers naturally have the best of everything on the steamers. They have, too, the courteous treatment of the officers on board and their comfort is looked after as carefully as if they had paid for a suite of rooms.

These steamers sail from Philadelphia on Saturdays and from Liverpool on Wednesdays, calling at Queenstown each way.

That the steamers of this service have merited the approbation of the traveling public, is evidenced by the large number of passengers they have carried in the past, the unqualified commendations from their patrons and by the growing demand each season for accommodations.

It will, no doubt, be of interest to the intending traveler to read a brief description of these steamers, together with some general information that will prove useful in the preparation for, and enjoyment of, an ocean voyage.

The Fleet

The Steamers on this Service are as follows: Haverford, Merion, Friesland, Westernland and Noordland.

The accompanying illustrations will give some idea of the saloons, staterooms and deck spaces of these steamers, but they do not set forth the equally attractive facts that everything is kept in excellent order,

1

2

AMERICAN LINE BROCHURE, C. 1906. This page from the American Line's brochure highlights its "Second Cabin" service on the Philadelphia-Queenstown-Liverpool route. As opposed to lines with two or three levels of service, cabin passengers on this route would all be treated equally and therefore "naturally have the best of everything." The photographs depict the SS *Haverford* and a scene with passengers enjoying her promenade deck. The sister ships *Haverford* and *Merion*, named for Philadelphia suburban townships, were twin-screw steamers built in 1901 and 1902 by John Brown Co. Ltd. of Clydebank. (Courtesy of Smithsonian Institution.)

AMERICAN LINE BROCHURE COVER. A fashionable Gibson girl gazes dreamily toward the open sea in this c. 1906 brochure cover. The brochure appeals to the traveler's desire for comfort and style, including descriptions of the various amenities aboard the ships *Haverford* and *Merion*. The ships were fully electrified. A well-furnished library, a ladies' parlor, and a spacious smoking room could all be accessed belowdecks. The "large and handsomely furnished" dining room was located off the saloon deck and included "an excellent piano." (Courtesy of Smithsonian Institution.)

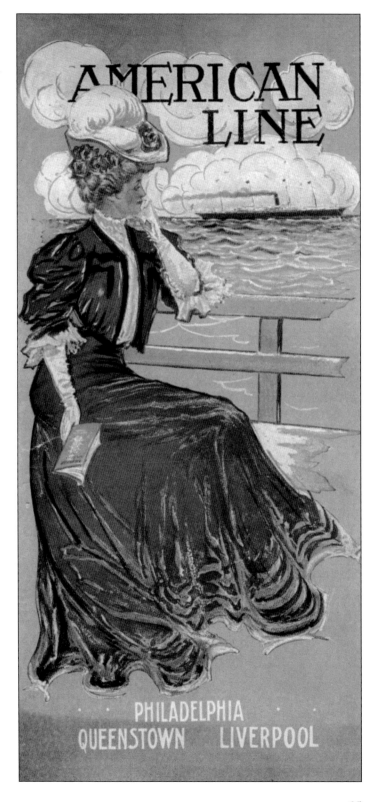

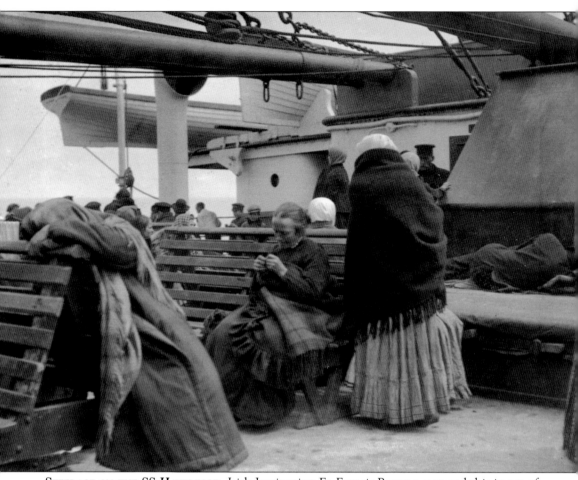

STEERAGE ON THE SS HAVERFORD. Irish Jesuit priest Fr. Francis Browne captured this image of steerage passengers aboard the SS *Haverford* in 1912. The steerage passengers would not experience the luxuries of the cabins and compartments above, sleeping in tiered wooden bunks and dining in the steerage hall. In addition to this compelling image, Father Browne is noted for having photographed the *Titanic* on the first leg of its tragic maiden voyage. He disembarked from the *Titanic* at Queenstown, where he likely took this photograph. (Courtesy of the Bridgeman Art Library and the Free Library of Philadelphia.)

Three

QUEEN VILLAGE

Today's Queen Village is the northernmost section of the old Southwark District. The boundaries extend from Lombard Street (one block north of the old Southwark boundary) southward to Washington Avenue and from Front Street westward to Sixth Street. A significant number of 18th- and 19th-century buildings remain standing in Queen Village, including 800 houses listed in the Philadelphia Historic Register. These properties are protected today, but in the 1960s and 1970s, over 130 Federal-era historic buildings were demolished to allow for the construction of the Delaware Expressway, otherwise known as Interstate 95. For a neighborhood that prided itself on its early architecture and intimate ties to the river, this was devastating. The Southwark Historic District was established in 1972 to protect the remaining houses in Queen Village. Gloria Dei (Old Swedes') Church, the oldest church in Pennsylvania, was already under protection as a National Historic Site. Pictured in this chapter are numerous buildings that are no longer standing. Among the most significant is the Union Volunteer Refreshment Saloon that operated at Washington Avenue and Swanson Street during the Civil War. Along with the nearby Cooper Shop Refreshment Saloon, the saloon offered Union soldiers a place to recuperate, wash, write letters, and take their meals. Southwark's seat of government, Commissioner's Hall, has also long since been demolished. It is pictured in this chapter as a reminder of Southwark's history as a district set apart from the city of Philadelphia.

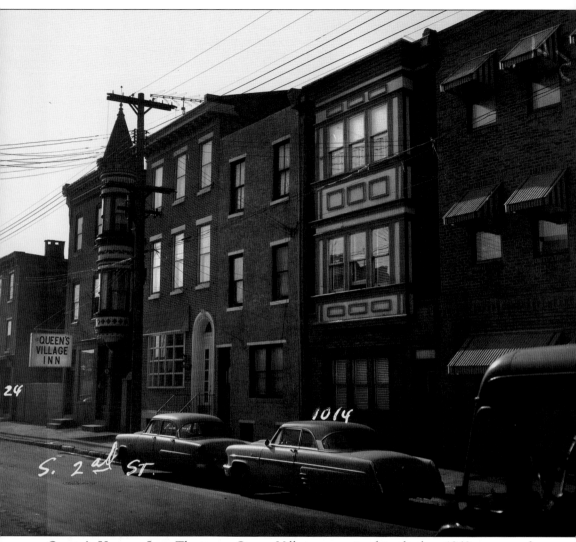

QUEEN'S VILLAGE INN. The name Queen Village was coined in the late 1960s as part of a neighborhood improvement effort. It honors the role of Queens Christina and Catherine of Sweden. A community of enthusiastic residents came together in the 1960s and 1970s to revitalize the community and rehabilitate historic properties that had fallen into disrepair. This photograph, taken in 1968, includes a Victorian town house with a projecting turret and a sign designating it as the Queen's Village Inn. The building today is home to Snockey's Oyster House, a local institution for lovers of bivalves. Founded in 1912, Snockey's was originally located on South Street. (Courtesy of PhillyHistory.)

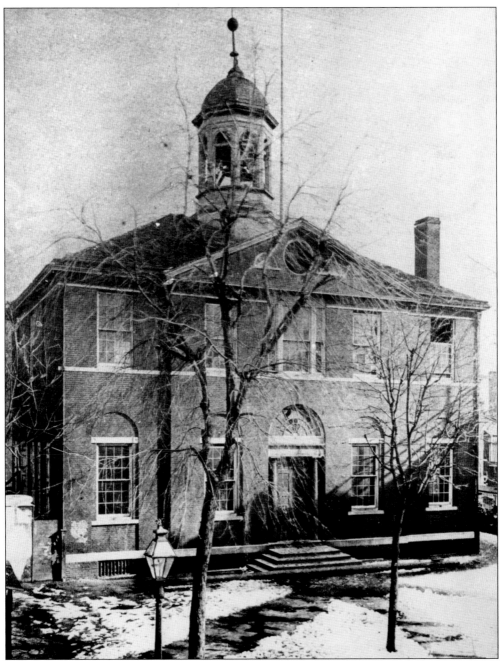

SOUTHWARK COMMISSIONER'S HALL. The center of Southwark's political activity once stood on the east side of Second Street, near Christian. Commissioner's Hall was a stately Neoclassical building topped with a distinctive bell tower and cupola. The building was set back from Second Street to accommodate a courtyard. This photograph offers a nice view of an old gas streetlamp topped with an eagle finial. Built in 1811, Commissioner's Hall was no longer needed following the consolidation of Southwark into Philadelphia in 1854. The hall was later used as the Second District police headquarters until it was demolished in the 20th century. (Courtesy of the Historical Society of Pennsylvania.)

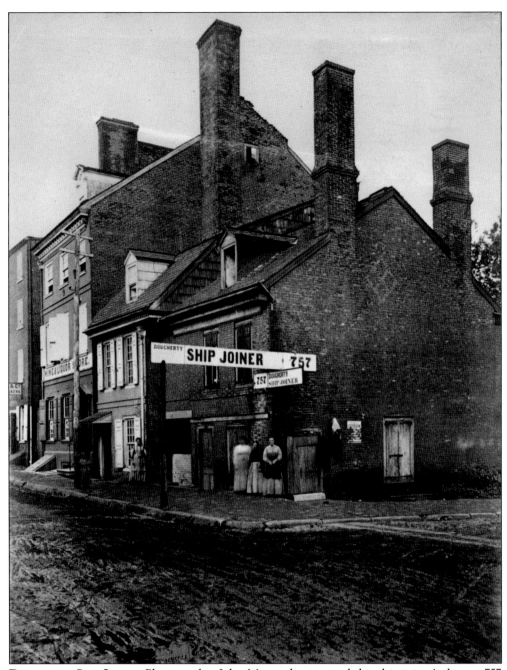

DOUGHERTY SHIP JOINER. Photographer John Moran documented this ship joiner's shop at 757 Swanson Street in 1868. The occupations of early Southwark residents were often tied to the nearby Delaware River, its shipping piers, and the old Navy Yard. Notice the diamond-shaped decorative brickwork on the side of the ship joiner's house. Brother to renowned painters Edward and Thomas Moran, John Moran was a prominent photographer who documented Philadelphia in the 1860s and 1870s. (Courtesy of the Free Library of Philadelphia.)

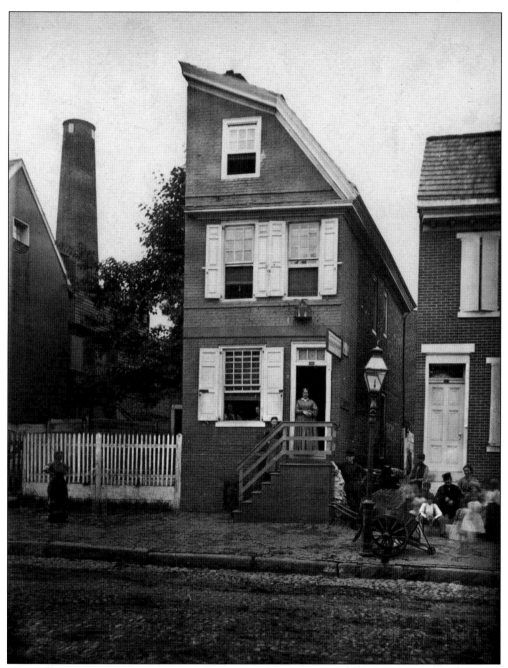

FRONT STREET, BELOW CHRISTIAN. John Moran's keen eye is readily apparent in this charming photograph dating to 1869. A row house on South Front Street stands without its "twin." The house's gambrel roof makes the absence look especially dramatic. The house's sign advertises the owner's services as a painter of houses, ships, and signs. The residents and their neighbors pose in front of their homes, with the wheelbarrow and gas streetlamp adding historic context to the scene. In the background, the Sparks Shot Tower peeks through the open space between the houses. (Courtesy of the Free Library of Philadelphia.)

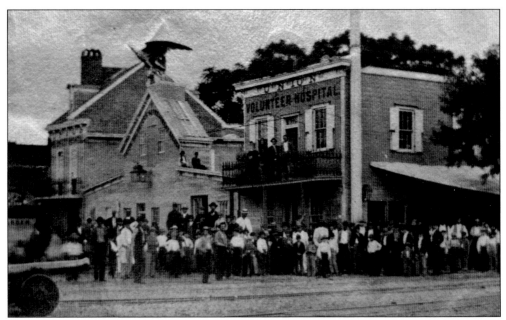

UNION VOLUNTEER REFRESHMENT SALOON. Founded in 1861, the brick building in the foreground served as an important source for supplies to the Union army during the Civil War. Southwark was home to two relief organizations that provided Union soldiers with a place to recuperate, wash, write letters, and take their meals. The Union Volunteer Refreshment Saloon and the Cooper Shop Refreshment Saloon stood at Washington Avenue and Swanson Street. (Courtesy of the Independence Seaport Museum.)

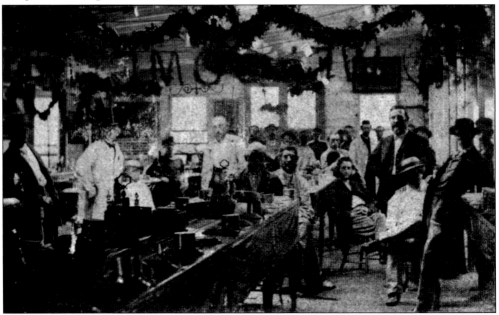

REFRESHMENT SALOON DINING HALL. This antique stereographic image provides a view inside the Refreshment Saloon's dining hall. The interior was decorated with festive garlands and Union flags. Above the heads of the seated gentlemen are garland letters spelling the word *welcome*. (Courtesy of the Free Library of Philadelphia.)

Weccacoe Fire Company Hosting Union Fire Company, c. 1851. James Fuller Queen's lithograph commemorates a reception for the firefighters of the United Fire Company of Baltimore. The Weccacoe firefighters are shown on the left wearing long belted jackets and capes. The firefighter in the foreground is turned to show the lettering on the back of his cape: "Weccacoe W.E.S." (Courtesy of the Historical Society of Pennsylvania.)

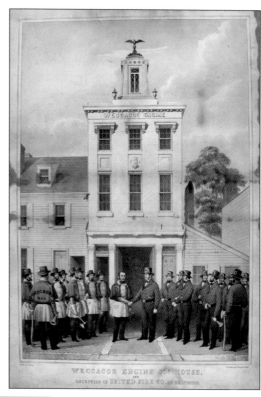

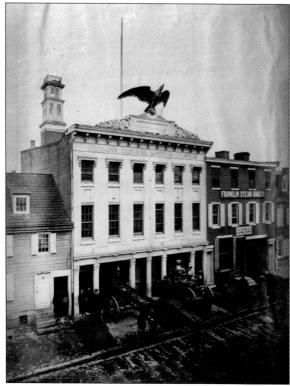

Weccacoe Fire Company. The engine house of the Weccacoe Fire Company was expanded with an additional three bays of windows and a garage door, doubling the house's size. Added to the building was a new cornice topped by an enormous eagle. Firemen demonstrate how the hose truck and engine are brought out from the garage doors. (Courtesy of the Historical Society of Pennsylvania.)

33

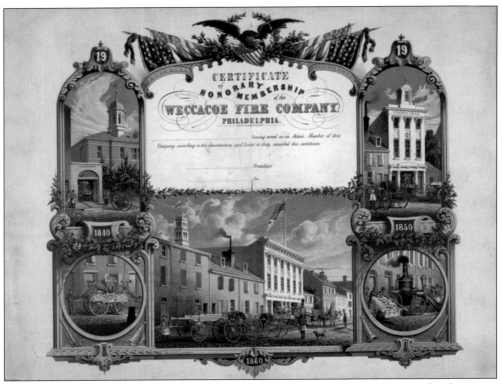

Certificate of Honorary Membership, Weccacoe Fire Company. Five vignettes on this decorative certificate illustrate the earlier fire station and the Southwark Commissioner's Hall flanking a central rendering of the expanded fire station. (Courtesy of the Library of Congress.)

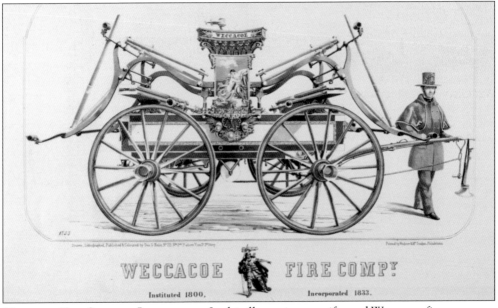

Weccacoe Fire Company Lithograph. In this illustration, a uniformed Weccacoe fireman poses with a fire engine. The print is inscribed, "Instituted 1800, Incorporated 1832." (Courtesy of the Historical Society of Pennsylvania.)

34

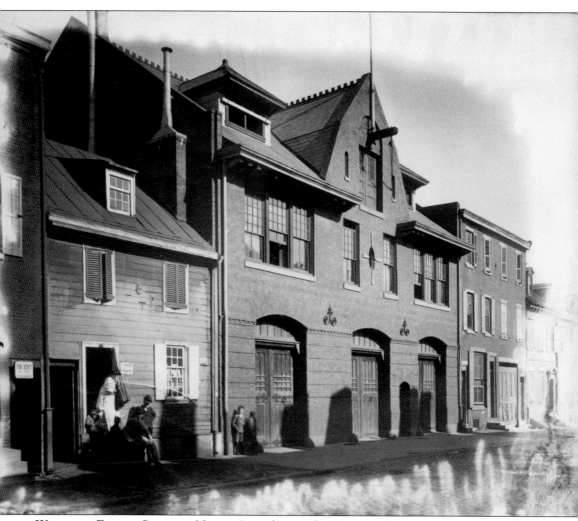

WECCACOE ENGINE COMPANY NO. 3. According to the Fireman's Museum, the city built this new facility after taking over the old volunteer fire company. The Historic American Buildings Survey dates this firehouse to about 1843. In 1893, the front was rebuilt, and a patrol house was added to the western side. (Courtesy of the Library of Congress.)

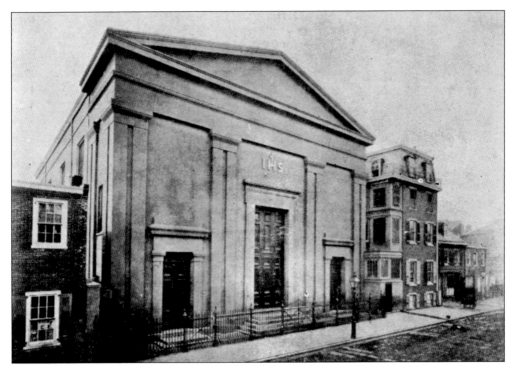

CHURCH OF ST. PHILIP NERI. The Church of St. Philip Neri was established in 1840. The building, which sits on the south side of Queen Street between Second and Third Streets, was the first commission by notable Philadelphia architect Eugene Napoleon LeBrun, whose other Philadelphia commissions include St. Augustine's Church, the Cathedral-Basilica of SS Peter and Paul, and the Academy of Music. (Courtesy of the Philadelphia Archdiocesan Historical Research Center.)

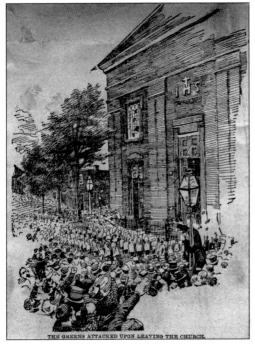

THE GREENS ATTACKED UPON LEAVING THE CHURCH.

NATIVIST RIOTS. The nativist movement arose in Philadelphia during the 1840s as Protestant residents reacted violently to the city's rapidly increasing Catholic immigrant population. In July 1844, the Church of St. Philip Neri called upon the state militia to protect the church against potential violence from nativists marching on Independence Day. The nativists were outraged, and deadly rioting ensued for three days. (Courtesy of the Free Library of Philadelphia.)

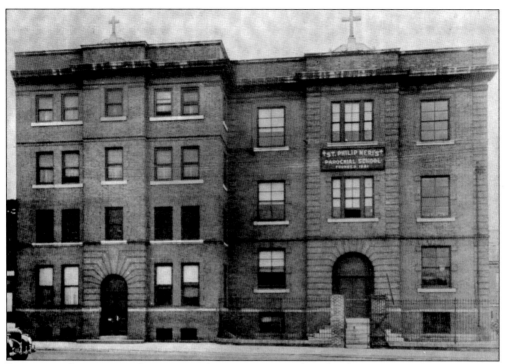

PAROCHIAL SCHOOL AND CONVENT OF ST. PHILIP NERI. The school constructed this much larger facility at Moyamensing Avenue and Christian Street in 1905. Enrollment eventually declined, and the school closed in 1991. (Courtesy of St. Philip Neri.)

ST. PHILIP NERI SCHOOL. The Church of St. Philip Neri was intentionally built on a raised foundation to allow for two classrooms and a chapel at ground level. The parish school was established in 1841, but the demand soon outgrew the space. The school expanded into buildings at 778 South Front Street and 408–410 Christian Street, pictured here. The school occupied these buildings from 1880 to 1904. (Courtesy of St. Philip Neri.)

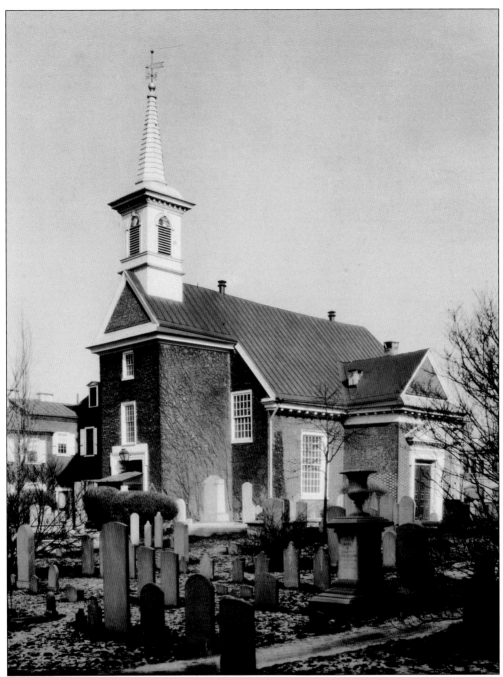

OLD SWEDES' (GLORIA DEI). The most iconic feature of Philadelphia's old Southwark District is the Gloria Dei Church, popularly known as "Old Swedes'." The church's roots extend back to the colony of New Sweden. The church was built between 1698 and 1700 to serve the Swedish settlement at Wicaco. It is the oldest standing church in Philadelphia and second-oldest in the United States. The Gloria Dei cemetery has been in continuous use since the 1700s and serves as a final resting place for noteworthy residents from Philadelphia's early years, including eight Revolutionary War officers. (Courtesy of the Historical Society of Pennsylvania.)

OLD SWEDES' CHURCH BUILDING. The original structure, built about 1700, was a simple rectangle. A tower was added in 1704, and later, a sacristy was built on the north side of the church, along with a vestibule on the south, creating a cruciform shape. This photograph of the chancel provides a close-up view of the handsome Flemish bond brick pattern. (Courtesy of PhillyHistory.)

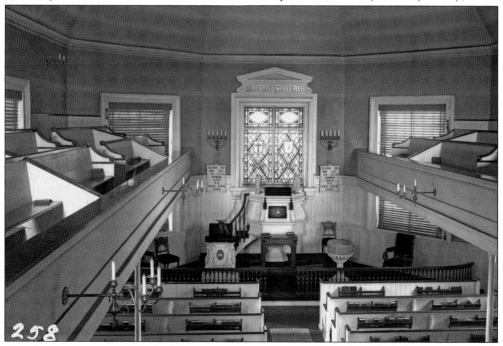

OLD SWEDES' INTERIOR. The building was renovated in the 1840s when the balcony and stained-glass window were added. This interior photograph was taken from the organ loft about 1900. (Courtesy of PhillyHistory).

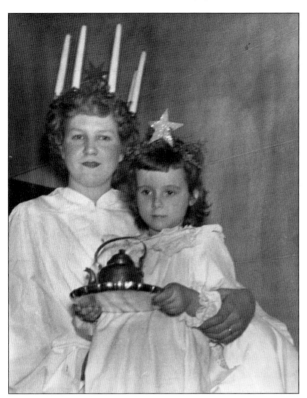

St. Lucia Festival. Old Swedes' has presented a St. Lucia pageant each year since the 1930s. St. Lucia Day is celebrated in Swedish communities each year at the winter solstice to honor St. Lucia, who symbolizes light and hope. The highlight of the children's pageant is the procession of an older girl dressed as St. Lucia, wearing a crown of candles. Along with one of the youngest girls, she offers tea and buns as a gesture of goodwill. (Courtesy of the Historical Society of Pennsylvania.)

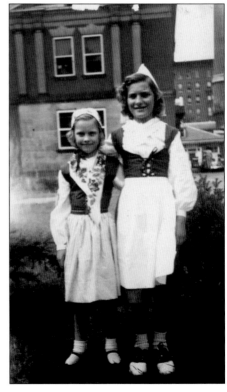

Girls at the Colonial Fair. On the first Saturday of June, Old Swedes' Church traditionally held a Colonial Fair. Children took part in traditional Swedish dancing as part of the festivities. (Courtesy of the Historical Society of Pennsylvania.)

Dr. Roak at the Colonial Fair. Among this group is Dr. John Craig Roak (far left), who served as Gloria Dei's rector from 1933 to 1972. (Courtesy of the Historical Society of Pennsylvania.)

Children at the Colonial Fair. Part of the fun of the annual Colonial Fair at Old Swedes' was dressing up in Swedish costume. (Courtesy of the Historical Society of Pennsylvania.)

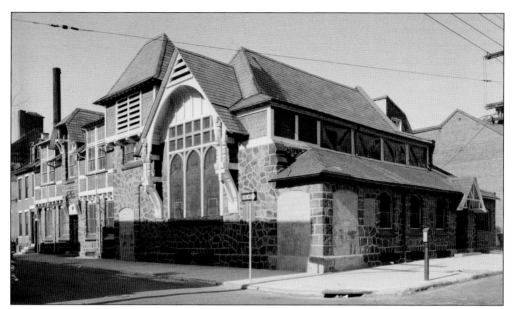

PROTESTANT EPISCOPAL CHURCH OF THE REDEEMER FOR SEAMEN AND THEIR FAMILIES. Designed by celebrated architect Frank Furness and built in 1878, this fanciful house of worship once stood at Front and Queen Streets. Furness's design paired a first story of random rubble stonework with a second story of half timber and half decorative brickwork. The roof incorporated a complex of projected eaves with decorative turned columns. (Courtesy of the Library of Congress.)

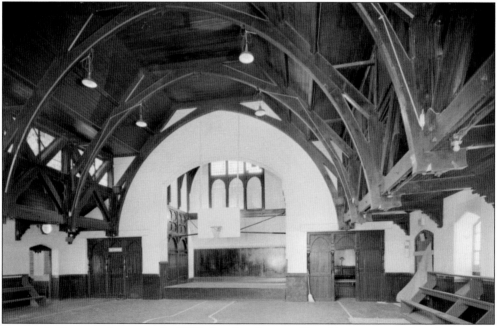

SEAMAN'S CHURCH, INTERIOR. In 1922, the church was sold and became a youth activity center and boys' club. This image shows that the chapel was repurposed as a gymnasium with a basketball court. Furness used a system of heavy trusses to create a Gothic arch ceiling with no columns or piers to obscure the view of the congregation—or get in the way of a good game! (Courtesy of the Library of Congress.)

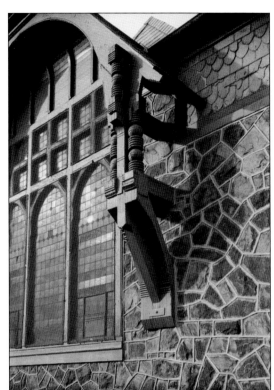

ARCHITECTURAL DETAILS. Frank Furness is known for his eclectic blend of styles and innovative techniques. Details like carved columns, decorative eaves, and fish-scale siding created quite a showstopper. The historically certified building burned down in 1974. (Both, courtesy of the Library of Congress.)

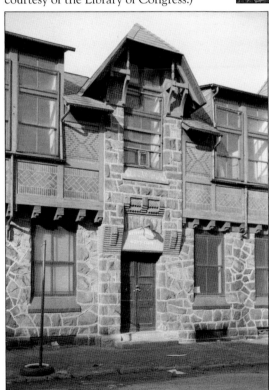

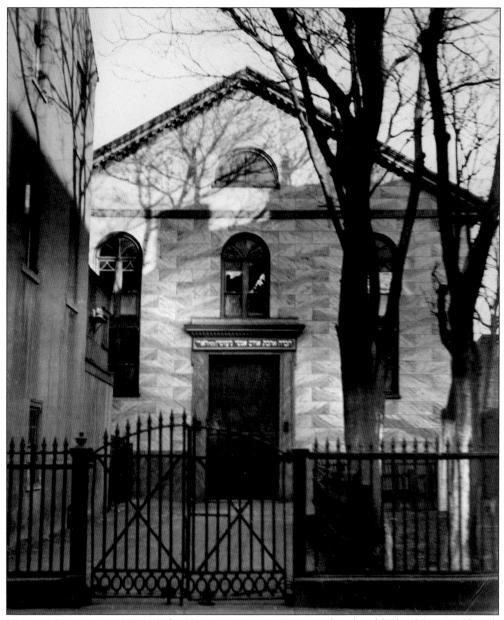

NEZINER SYNAGOGUE. In 1905, the Neziner congregation moved to the old Third Baptist Church building at 771 South Second Street. At that point, the neighborhood was firmly established as the Jewish Quarter, and Neziner was among a network of synagogues and small businesses. In bold Hebrew lettering, the congregation name is visible above the synagogue's entrance in this c. 1940 photograph. (Courtesy of the Special Collections Research Center, Temple University Libraries.)

NEZINER SYNAGOGUE, INTERIOR AND TORAHS. The hand-carved wooden ark holding the congregation's Torahs was placed on the synagogue's eastern wall. In the early 1940s, Dr. John Craig Roak of Gloria Dei Church began holding interfaith services with the Neziner congregation in an effort at greater understanding among the neighborhood's diverse religious groups. (Courtesy of the Special Collections Research Center, Temple University Libraries.)

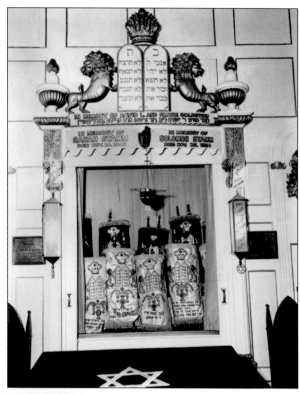

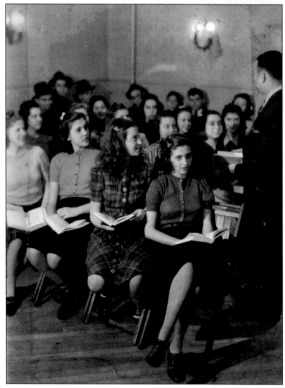

HEBREW SUNDAY SCHOOL SOCIETY. This photograph depicts a Hebrew Sunday school class meeting at Neziner Synagogue. (Courtesy of the Special Collections Research Center, Temple University Libraries.)

EMANUEL GERMAN EVANGELICAL LUTHERAN CHURCH, VIEW FROM THE WEST. The Emanuel German Evangelical Lutheran Church opened at Fourth and Carpenter Streets in 1869 to serve Southwark's German population, many of whom previously worshipped in the area's Swedish churches. The church's elaborate 187-foot-tall steeple featured clockworks by Berlin's renowned Von Christian Mollinger firm and three bells cast by a local Philadelphia foundry. (Courtesy of PhillyHistory.)

EMANUEL GERMAN EVANGELICAL LUTHERAN CHURCH, VIEW FROM THE NORTH. Emanuel Lutheran's congregation remained strong through the turn of the 20th century; however, the church began to suffer as the neighborhood's German population moved to the outskirts of the city and the congregation shrank. The congregation was forced to relocate in 2008, and the church now serves as a Buddhist temple. (Courtesy of PhillyHistory.)

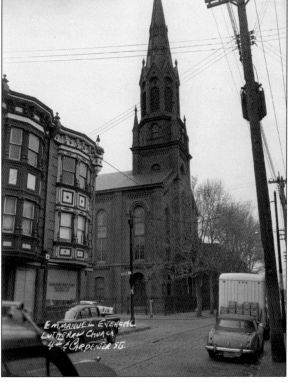

MARINERS' BETHEL METHODIST EPISCOPAL CHURCH. The cornerstone for this church was laid in 1873 on the northwest corner of Washington and Moyamensing Avenues. (Courtesy of the Special Collections Research Center, Temple University Libraries.)

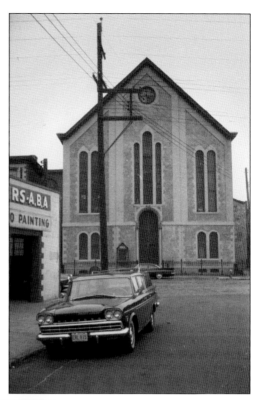

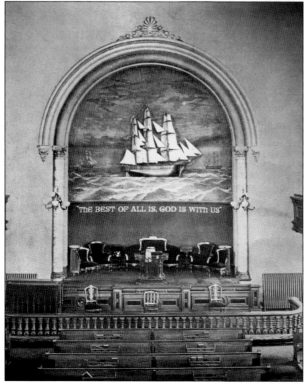

MARINERS' BETHEL METHODIST EPISCOPAL CHURCH, INTERIOR. The dramatic altar painting at Mariners' Bethel bears the inscription "The Best of All Is, God Is With Us." (Courtesy of the Special Collections Research Center, Temple University Libraries.)

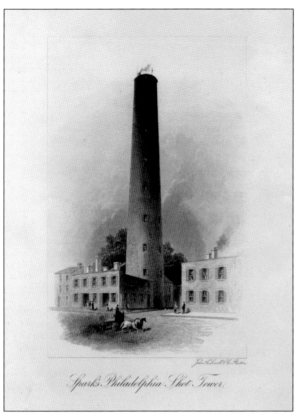

Sparks Philadelphia Shot Tower

SHOT TOWER ENGRAVING. The Sparks Shot Tower, or Southwark Shot Tower, was erected in 1808 at Front and Carpenter Streets for production of lead shot. Standing close to 150 feet tall, the tower was one of the earliest of its kind in the United States. The manufacturing process leveraged gravity to shape molten lead into a sphere as it traveled down the length of the tower before plunging into a vat of water and hardening. (Courtesy of the Historical Society of Pennsylvania.)

SHOT TOWER IN CITYSCAPE. The shot tower remains a distinctive point of interest in Philadelphia's skyline. This view looking toward Center City was taken from the east. (Courtesy of the Free Library of Philadelphia.)

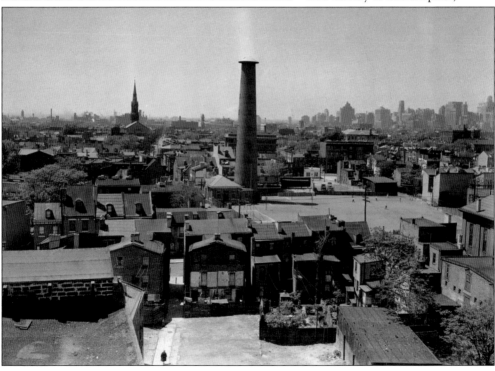

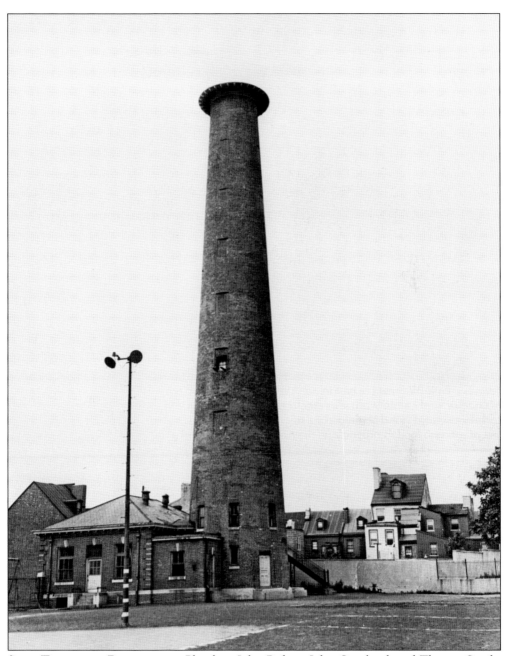

Shot Tower and Playground. Plumbers John Bishop, John Cousland, and Thomas Sparks founded the Sparks Shot Tower in response to high prices of shot due to the Embargo Act of 1807. Initially, the factory produced shot for sport purposes, but it then turned to munitions supply during the War of 1812. This involvement with the war provoked Bishop, a Quaker, to retire and divest his interest in the enterprise. Under management of the Sparks family, the facility went on to manufacture conical shot during the Civil War. Three generations of Sparkses continued the manufacture of shot at this location until 1903. In 1913, the City of Philadelphia took over the property for use as a playground, which remains open to the public today. (Courtesy of PhillyHistory.)

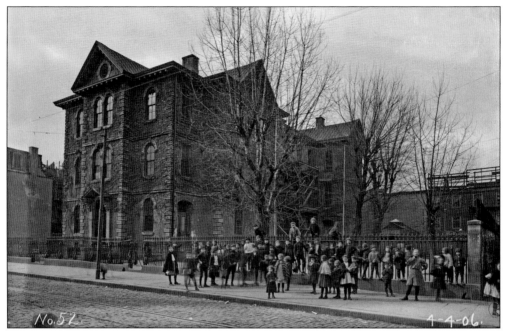

MOUNT VERNON SCHOOL BUILDING. Mount Vernon Grammar School was built on the northwest corner of Third and Catharine Streets in 1820. That building was used as a cholera hospital during the outbreak of 1832. The original school was demolished in 1873, and the new school, pictured here, was built that same year. (Courtesy of PhillyHistory.)

MOUNT VERNON SCHOOL YARD. The children of the Mount Vernon School enjoy a sunny day outdoors in this photograph. (Courtesy of PhillyHistory.)

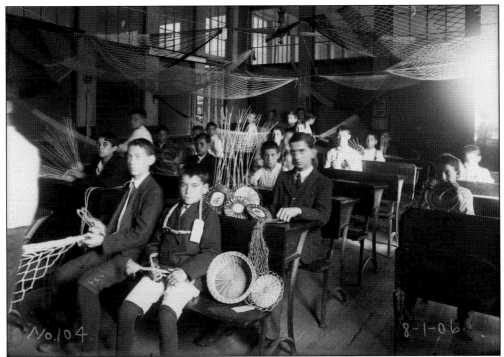

MOUNT VERNON SCHOOL CLASSROOM, BOYS. The boys in this 1906 photograph of a Mount Vernon School classroom are engaged in a basket-weaving project. (Courtesy of PhillyHistory.)

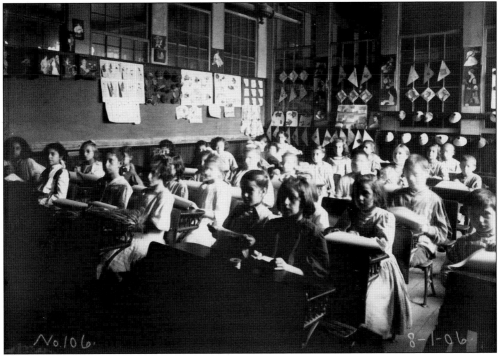

MOUNT VERNON SCHOOL CLASSROOM, GIRLS. This photograph, also dating to 1906, shows a classroom of mostly girls. The walls are decorated with art projects. (Courtesy of PhillyHistory.)

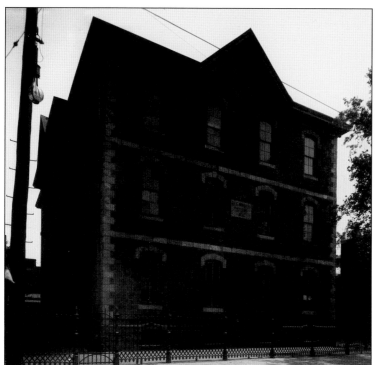

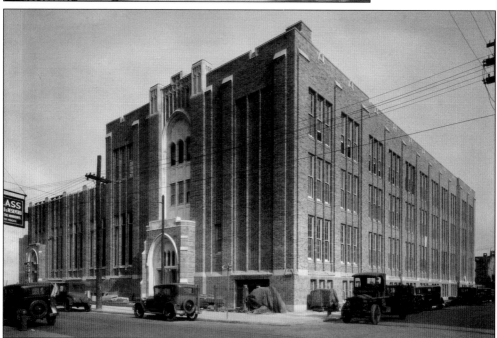

WILLIAM M. MEREDITH SCHOOL, REBUILT. The Meredith School was rebuilt in 1930 in an Art Deco design by architect Irwin T. Catherine. When Catherine was appointed architect to Philadelphia Schools in 1920, he undertook a campaign of renovation and rebuilding throughout the city. He sought to modernize public schools and provide amenities like indoor bathrooms and cafeterias. (Courtesy of PhillyHistory.)

Four

THE JEWISH QUARTER MARKETS

From the 1880s through the 1930s, much of today's Queen Village was known as the Jewish Quarter. South Street was the main hub of Jewish life in Philadelphia, with fully stocked storefronts overflowing into curbside displays. South Fourth Street was also a bustling shopping area known as Der Ferder ("The Fourth" in Yiddish) among the Jewish community. The market's shops offered kosher meats, fish, produce, dairy products, and miscellaneous dry goods. Shop owners often operated on the first floor of their home. In addition to the shops of South Fourth Street, street vendors purchased licenses to operate pushcarts and stands along the curb. Pushcarts and shops also offered fabrics, sewing supplies, and curtains. The Jewish Quarter had close ties to the textile trade, as many of the neighborhood's residents worked as seamstresses in the neighborhood sweatshops. The fabric shops were busy during the Depression, when sewing one's own clothes was an economic necessity for many. The pushcarts were banned in the 1950s, signaling the beginning of changes to the population of Southwark's Jewish Quarter market. Following World War II, a period of prosperity set in for the Fourth Street vendors. Much of the neighborhood's Jewish population relocated to nearby suburban areas, and vendors began commuting to their shops rather than living above them. In 1996, South Fourth Street fabric shop owners successfully lobbied for the official designation of Fabric Row. This chapter offers a glimpse into the hustle and bustle of the old Jewish Quarter marketplace, with a focus on South Fourth Street and the adjacent South Street shopping area.

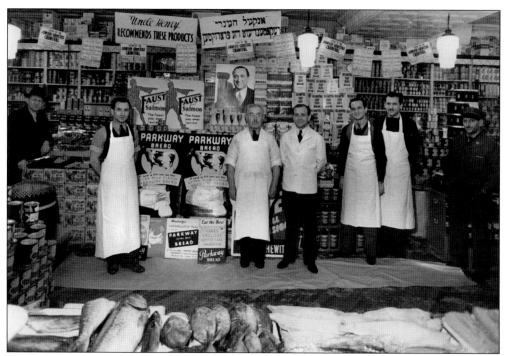

FAMOUS DELI, C. 1933. The Auspitz family emigrated from Poland and established the Famous Deli on the southwest corner of Fourth and Bainbridge Streets in 1923. The family ran the Famous Deli for three generations. In 2005, the business was purchased and refurbished, faithfully retaining its quality and character as a classic Jewish deli. (Courtesy of the Special Collections Research Center, Temple University Libraries.)

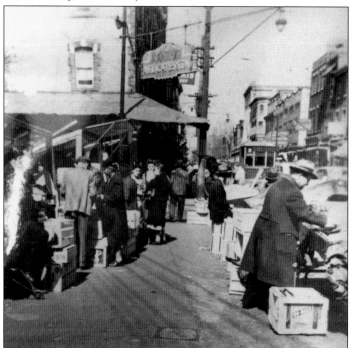

DELICATESSEN, 1946. The street market bustles with activity outside of this delicatessen on the northwest corner of Bainbridge and Fourth Streets. In the background, along comes the Catherine-Bainbridge Street trolley to carry shoppers to and from the market. (Photograph by Charles Zemaitaitis, courtesy of Elizabeth Aros.)

MARGOLIS KOSHER WINE. This c. 1933 photograph focuses on a kosher wine shop at the corner of Fourth and Monroe Streets. The presence of a liquor store marks the end of the Prohibition era. Rubin's Yarns and Zinkin's Fabrics are visible farther down Fourth Street. (Courtesy of the Special Collections Research Center, Temple University Libraries.)

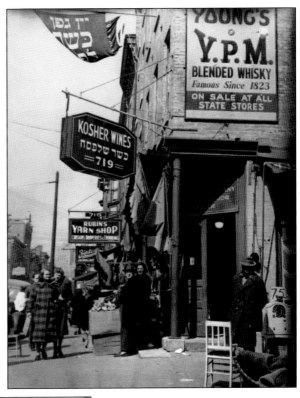

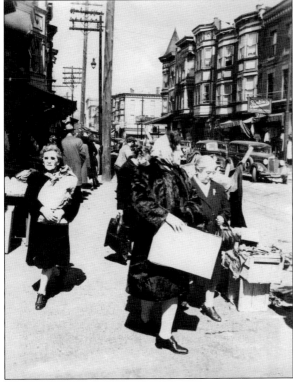

SHOPPING ON SOUTH FOURTH STREET. On March 24, 1946, Charles Zemaitaitis took this charismatic snapshot of people on South Fourth Street. Note the shopper who hurries home with her purchase tucked into a paper bag as well as the shoppers who slowly stroll while perusing the vendors' selection. Across the street, the Victorian buildings are outfitted with awnings to protect merchandise from the elements. (Courtesy of Elizabeth Aros.)

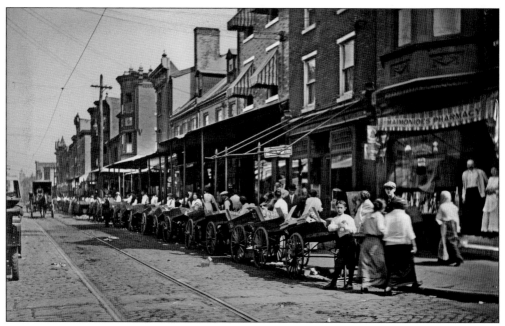

Pushcart Market on South Fourth Street, 1914. This image was taken during the heyday of the pushcart market. In the background is Maimonides Pharmacy, aptly named for the preeminent Hebrew scholar and physician of the Middle Ages. (Courtesy of PhillyHistory.)

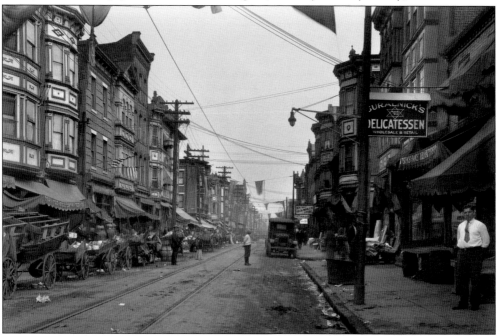

Pushcart Market on South Fourth Street, 1926. Carts brimming with produce line the west side of South Fourth Street in this photograph. The awnings above announce the names of the shop vendors in Hebrew and English, such as Guralnick's Delicatessen. The other shops on this side of the street, including the New York Silk and Woolen Store, display stacks of folded and rolled fabrics. (Courtesy of PhillyHistory.)

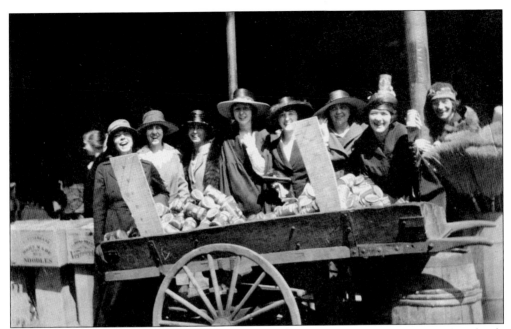

SHOPPERS AT THE PUSHCART MARKET. This group of fashionably dressed women smiles for a family photograph at Bainbridge and South Fourth Streets. The pushcart, brimming with goods, serves as a charming prop. (Courtesy of the Special Collections Research Center, Temple University Libraries.)

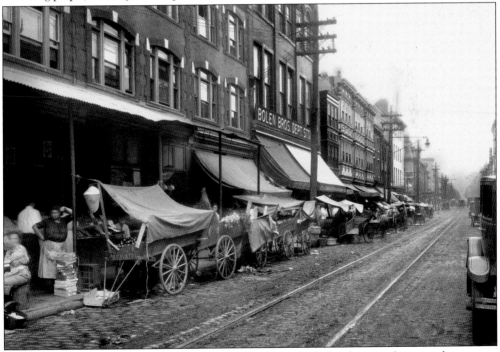

PUSHCARTS AND AWNINGS ON SOUTH FOURTH STREET, 1926. On the cart closest to the camera, the owner's name, Ziskin, and address, on Fitzwater Street, are visible. A large rustic cloth tied to the metal supports of the awning protects Mrs. Ziskin's produce. Farther down the street is the Bolen Bros. Department Store, as well as several discount grocers. (Courtesy of PhillyHistory.)

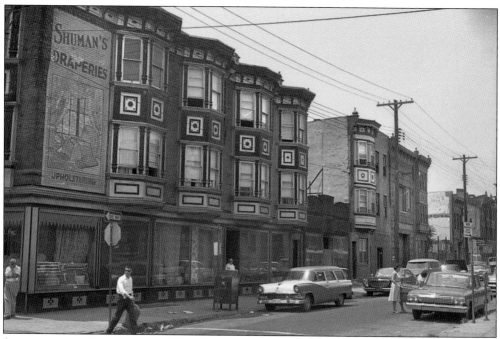

SHUMAN'S DRAPERIES. Located at South Fourth and Fitzwater Streets, Shuman's Draperies operated at this site between 1931 and 1969. (Courtesy of PhillyHistory.)

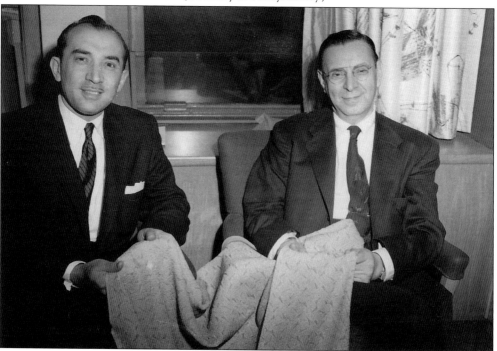

BUYING TRIP IN NEW YORK. This photograph shows Phil Morgenstern (left) and Louis Winitsky, partners in Winitsky & Co. and Win-tex Fabrics at 724 South Fourth Street, on a 1950s buying trip in New York. Their other partner, Max Rapoport, was most likely in Philadelphia minding the store. (Courtesy of Michele Palmer.)

CORNER OF FIFTH AND SOUTH STREETS. A policeman directs traffic at the intersection of Fifth and South Streets. The crisscross trolley tracks indicate the juncture of the widely used Fifth-Sixth Street and Bainbridge-Catherine trolley lines. A soda fountain on Fifth Street beckons passersby with signage offering ice cream, and presumably, ice cream floats. (Photograph by Charles Zemaitaitis, courtesy of Elizabeth Aros.)

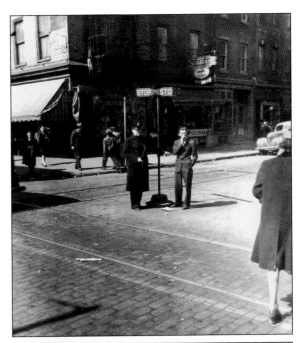

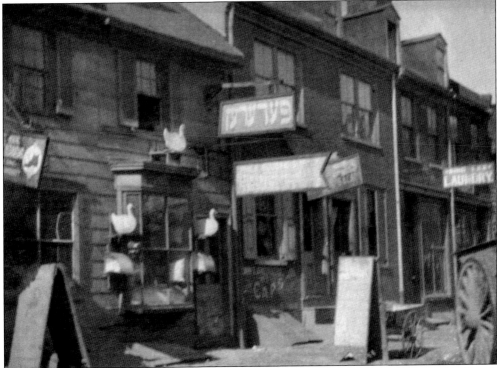

SOUTH FIFTH STREET NEAR BAINBRIDGE, 1903. Helen C. Jenks photographed this block of South Fifth Street on behalf of the Octavia Hill Association. Among the assorted shop fronts is a store with signage lettered in Hebrew and wooden ducks, presumably advertising poultry services. A pushcart parked on the sidewalk and a carriage wheel reflect the period's modes of local transportation. (Courtesy of the Special Collections Research Center, Temple University Libraries.)

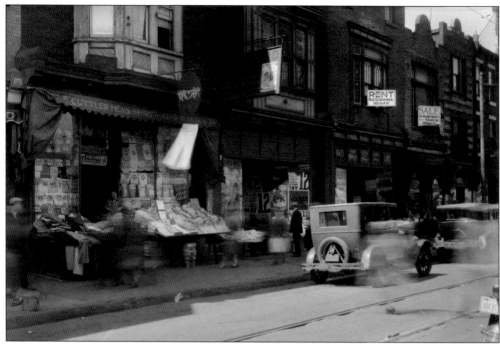

300 SOUTH STREET, 1930. Here, S. Cuttler's shop sells men's shirts, pants, caps, and King Kard overalls. (Courtesy of PhillyHistory.)

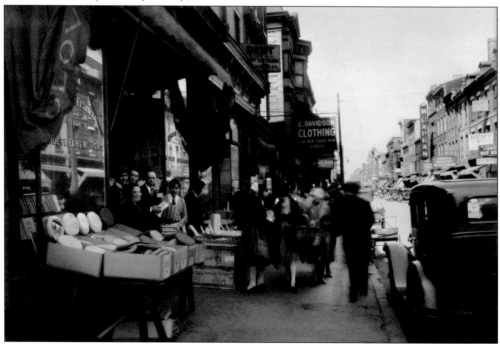

300 BLOCK OF SOUTH STREET. A person could buy just about anything on South Street in the Jewish Quarter. This photograph shows all manner of shops. Morris Fishman's shop in the foreground advertises underwear and notions. The outdoor display includes an array of men's caps. Other shops advertise hosiery, hats, clothing, and Natural Bloom cigars. (Courtesy of PhillyHistory.)

Five

CHARITABLE ORGANIZATIONS

Since Southwark's earliest days of European settlement, the area had always been home to immigrant communities. Those who settled in Southwark in the 18th, 19th, and early 20th centuries often did so because housing was affordable and other immigrants from their native soil had also settled there. Although these ethnic enclaves often provided support to new community members, outside organizations played a key role in providing assistance to Southwark's needy residents. The Southwark Soup Society, for example, was one of many organizations in Philadelphia based on the English model of charitable soup societies. The Bethesda Rescue Mission provided food and shelter to Southwark's neediest people. These organizations provided meals and a roof to alleviate the immediate needs of food and shelter. Southwark's residents required assistance beyond these very basic needs, however, such as education, socialization, and improved housing conditions. Two organizations addressed these social factors to a high level of efficacy—the College Settlement and the Octavia Hill Association.

This chapter's content focuses on these two prominent and influential organizations that shaped Southwark's people and places in the late 19th and early 20th centuries.

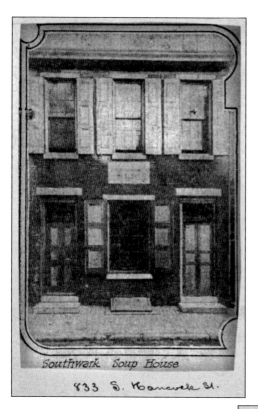

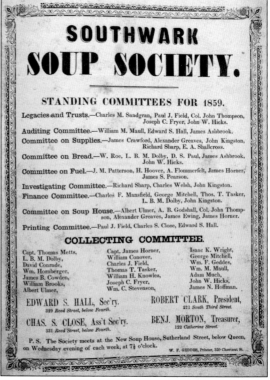

SOUTHWARK SOUP HOUSE. The Southwark Soup Society was founded in 1805 to serve Southwark's "deserving poor." Tickets were distributed to the needy, who then redeemed them at the soup house, which was located at 833 South Sutherland Street (now Hancock Street). (Courtesy of the Historical Society of Pennsylvania.)

SOUTHWARK SOUP SOCIETY 1859 REPORT. The society distributed thousands of gallons of soup and thousands of loaves of bread during the frigid winter months. The first of many charitable food organizations in Philadelphia, the Southwark Soup Society merged with the Union Benevolent Association in 1949. (Courtesy of the Historical Society of Pennsylvania.)

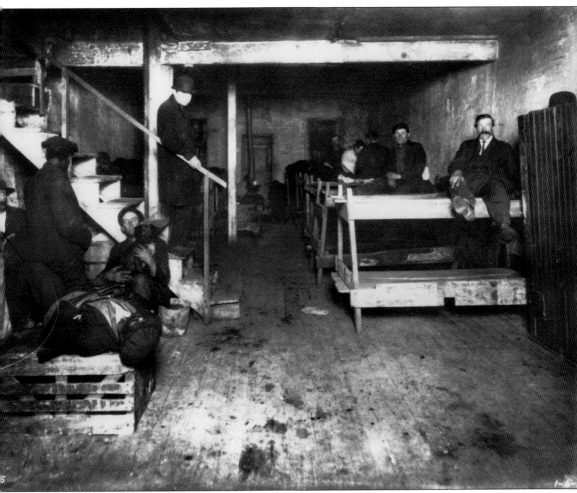

BETHESDA RESCUE MISSION. Housed at 119 South Street, the Bethesda Rescue Mission provided shelter, bunks, and meals to those in need. In addition to serving Philadelphia's homeless and transient adult populations, the organization offered services to needy children. An article published in the June 25, 1913, issue of the *Philadelphia Inquirer* highlights a children's excursion held by the mission. With lunch and entertainment, 200 children were ferried on the Delaware River to Burlington Island Park. (Courtesy of PhillyHistory.)

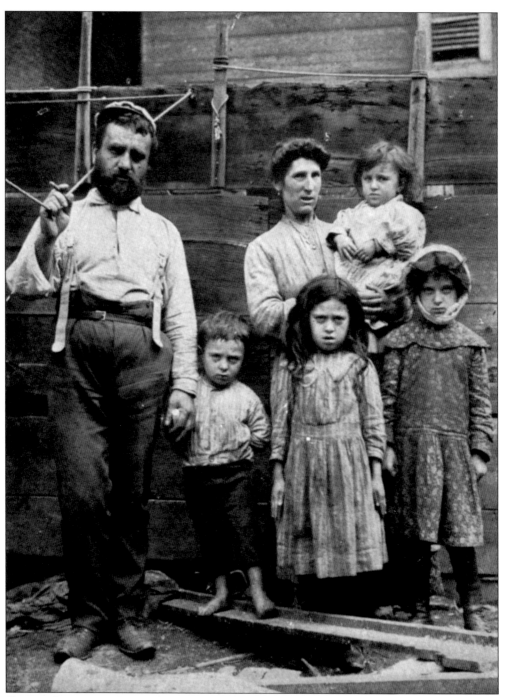

COLLEGE SETTLEMENT HOUSE, IMMIGRANT FAMILY. Founded in 1889 by college-educated reformists, primarily women, the College Settlement assisted numerous needy populations in Philadelphia. The College Settlement in Southwark worked primarily with the Russian Jewish immigrant community in the neighborhood's Jewish Quarter. This photograph was published in 1916 by the College Settlement to depict the conditions faced by an immigrant family. (Courtesy of the Historical Society of Pennsylvania.)

CHILDREN AT COLLEGE SETTLEMENT DOORWAY. In 1889, the College Settlement moved its location to 431–433 Christian Street, pictured here. This c. 1909 photograph includes the following caption: "To be a supporter of the College Settlement means that you have a vision of brotherhood wherein no man lives unto himself; of a neighborhood where no man may fall among thieves; of a house wherein are many mansions and no dark rooms; of a freedom that is perfect service." (Courtesy of the Historical Society of Pennsylvania.)

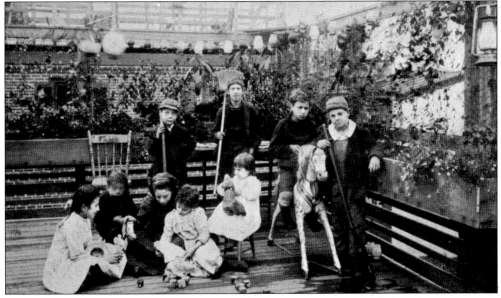

COLLEGE SETTLEMENT ROOF GARDEN. The College Settlement's roof garden offered a sheltered respite from the congested and often unsanitary streets of Southwark. A rocking horse, baby blocks, and book offer recreation for these children of various ages. Greenery grows in wooden planters that line the roof deck, with climbing vines reaching skyward. (Courtesy of the Historical Society of Pennsylvania.)

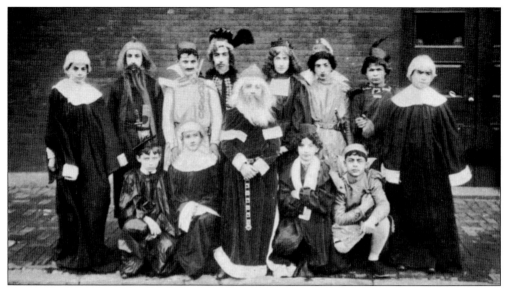

College Settlement Dramatic Club. The cast of Shakespeare's *The Merchant of Venice*, as performed by the College Settlement's Dramatic Club, is shown here about 1900. In the center of the group stands the bearded Shylock, the drama's notorious, vengeful Jewish moneylender. (Courtesy of the Historical Society of Pennsylvania.)

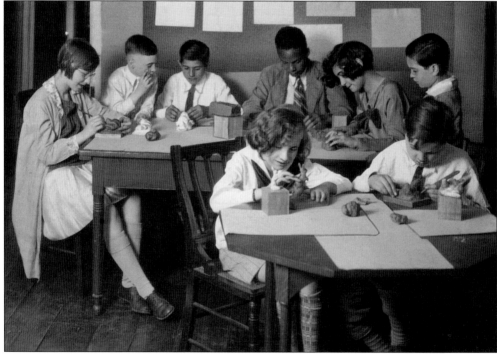

Children at the Settlement Music School. The College Settlement expanded in 1908 when two young women—Jeannette Selig Frank and Blanche Wolf Kohn—founded the Settlement Music School. As the music program grew, the staff included some members of the Philadelphia Orchestra. In this 1932 photograph, children create clay figures at the Settlement Music School's building on Queen Street. (Courtesy of the Historical Society of Pennsylvania.)

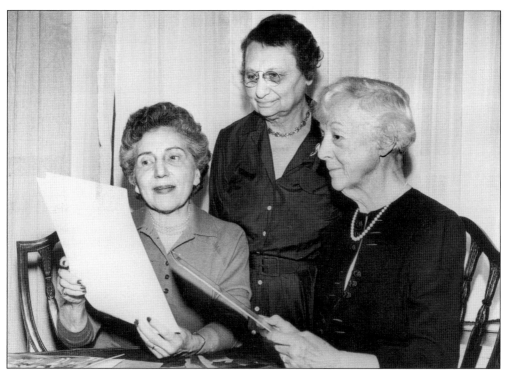

MARY LOUISE CURTIS AND FOUNDING MOTHERS. The founding mothers of the Settlement Music School, Jeannette Selig Frank (left) and Blanche Wolf Kohn (center), are pictured with Mary Louise Curtis Bok, who funded the construction of the Settlement Music School building. In 1924, Bok founded the Curtis Institute of Music, Philadelphia's premier music conservatory. (Courtesy of the Settlement Music School.)

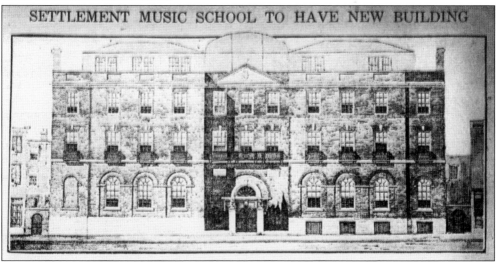

SETTLEMENT MUSIC SCHOOL BUILDING. The caption for this sketch in the January 27, 1916, *Evening Public Ledger* announces the building of the Settlement Music School's new home at 416 Queen Street. Mary Louise Curtis Bok, the only child of publishing magnate Cyrus H.K. Curtis, funded the project at a cost of $150,000. (Courtesy of the Pennsylvania Historical Newspapers archive at the Free Library of Philadelphia.)

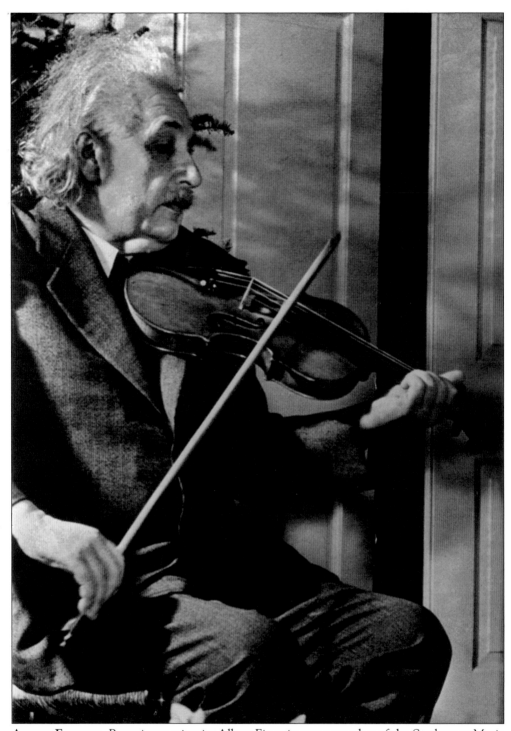

ALBERT EINSTEIN. Preeminent scientist Albert Einstein was a member of the Settlement Music School's board of advisors as well as a regular chamber music participant in the 1950s. (Courtesy of the Settlement Music School.)

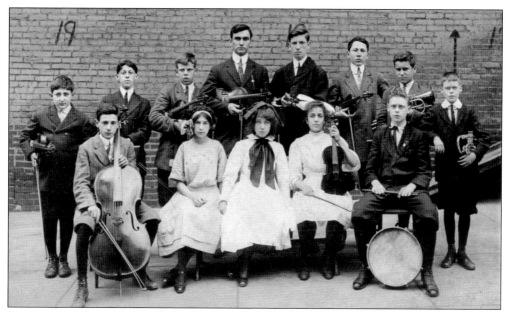

SETTLEMENT MUSIC SCHOOL BAND. In the early days of the Settlement Music School, its mission was to provide musical training to immigrant children. This photograph taken in the 1910s shows an ensemble of young musicians holding their instruments. (Courtesy of the Settlement Music School.)

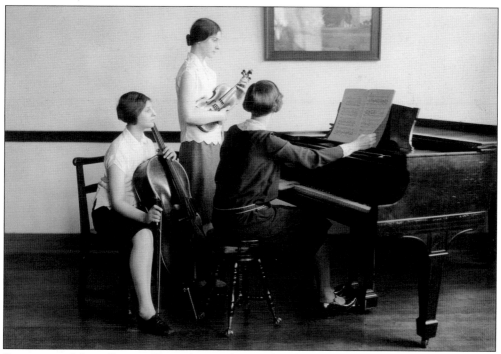

SETTLEMENT MUSIC SCHOOL TRIO. A trio of young female musicians discusses a composition in this historic photograph of the Settlement Music School. Many students from the Settlement Music School went on to study at the Curtis Institute of Music and became professional musicians. (Courtesy of the Settlement Music School.)

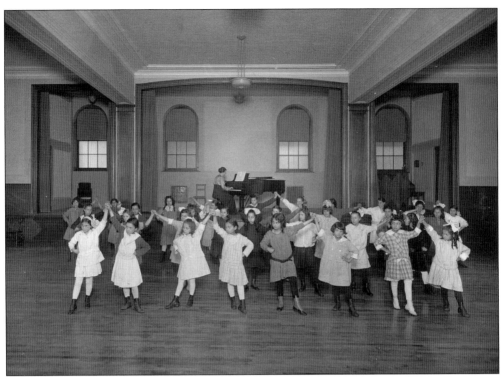

SETTLEMENT MUSIC SCHOOL DANCING. Here, a pianist plays for a dance rehearsal at the Settlement Music School. The girls, many of whom are presumably from Southwark's immigrant communities, hold a pose as they dance in pairs. (Courtesy of the Settlement Music School.)

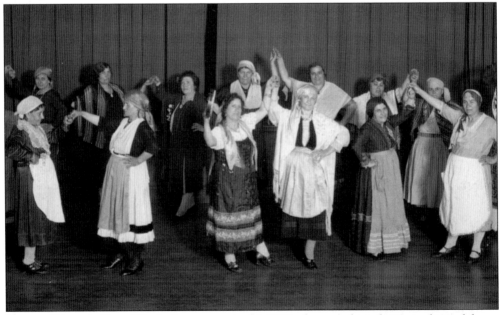

ITALIAN WOMEN'S CLUB. The Italian women in this 1930s photograph perform a traditional dance on stage at the Settlement Music School. Dressed in Italian folk costumes, some of the dancers also play tambourine. (Courtesy of the Historical Society of Pennsylvania.)

SETTLEMENT MUSIC SCHOOL CHORAL ENSEMBLE. The pianist is seated in a Windsor chair, offering vocal coaching to the girls who are gathered around the piano. The studio is bathed in light streaming through the building's ample windows. (Courtesy of the Settlement Music School.)

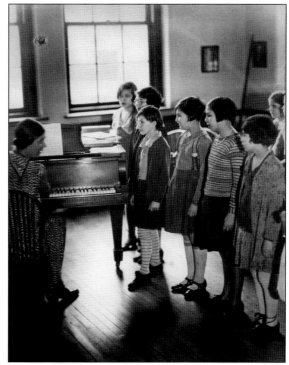

SETTLEMENT MUSIC SCHOOL CLASS. Surrounded by her classmates, a young girl is seated in a Windsor chair at the piano in this image. The photograph dates to 1932, and the bob haircuts worn by the girls reflects the fashion of the early 1930s. (Courtesy of the Settlement Music School.)

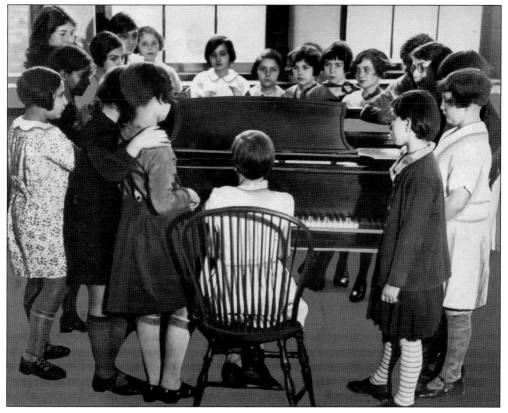

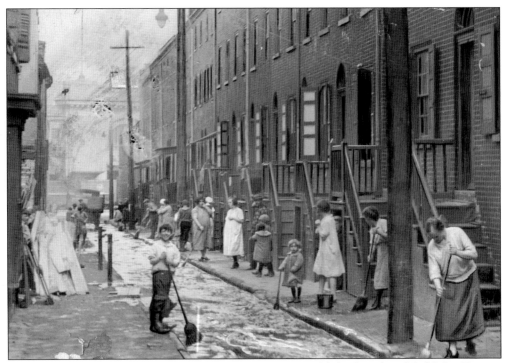

Residents of Beck Street, Sweeping. This image was published in the *Philadelphia Evening Bulletin* on September 14, 1927. The scene demonstrates a South Philadelphia tradition of sweeping one's stoop and flushing the street with water. (Courtesy of the Special Collections Research Center, Temple University Libraries.)

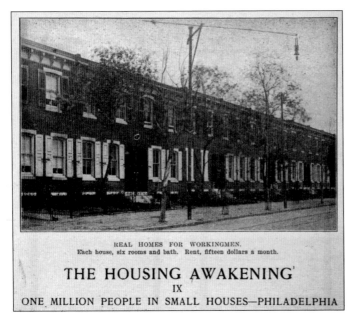

REAL HOMES FOR WORKINGMEN.
Each house, six rooms and bath. Rent, fifteen dollars a month.

THE HOUSING AWAKENING
IX
ONE MILLION PEOPLE IN SMALL HOUSES—PHILADELPHIA

One Million People in Small Houses. This image comes from the National Housing Association's Housing Awakening Series, Part IX, published in 1911 by Octavia Hill Association founder Helen C. Jenks, who argues against "the evils of tenement houses" in favor of small homes that house single families. She believed that low-income families would benefit from occupying and maintaining a small home of their own, which "fosters a conservative, law-abiding element in the community." (Courtesy of the Historical Society of Pennsylvania.)

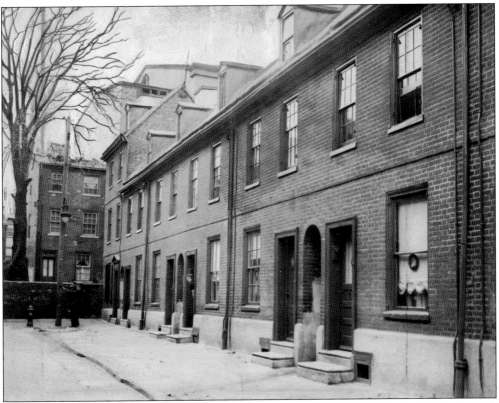

BECK STREET ROW HOUSES. The Octavia Hill Association provided residents of Beck Street with amenities that improved the quality of life on their street. This photograph from the *Philadelphia Evening Bulletin* of January 4, 1941, shows a tidy street in good repair. (Courtesy of the Special Collections Research Center, Temple University Libraries.)

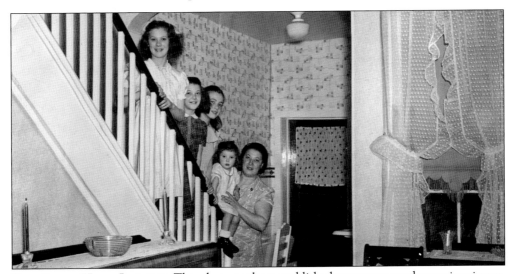

BECK STREET HOME, INTERIOR. This photograph was published to accompany the previous image. It illustrates a Beck Street family who was assisted by the Octavia Hill Association. (Courtesy of the Special Collections Research Center, Temple University Libraries.)

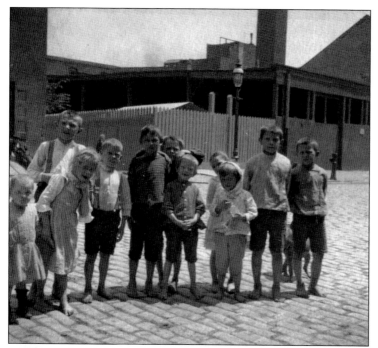

FRONT AND LEAGUE STREETS. Helen C. Jenks documented this group of children in August 1905. In *Good Housing that Pays*, Jenks describes the formerly deplorable conditions at League Street. She writes, "With unwearied patience the Association strove to create among the people in its houses a sense of thrift, of honor, of self-respect, even of community spirit." (Courtesy of the Special Collections Research Center, Temple University Libraries.)

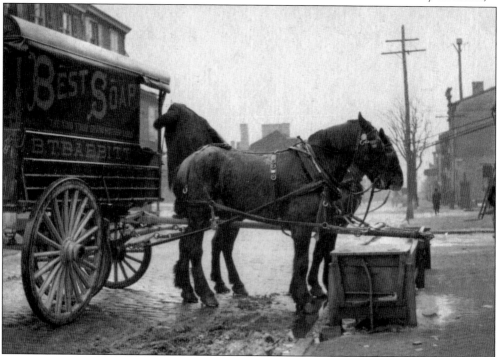

BABBITT'S BEST SOAP WAGON. In this scene, the B.T. Babbitt Soap salesman hitches his horses to a watering trough at Front and League Streets. The wagon advertises Babbitt soap as "The Kind Your Grandmother Used." Taken by Helen C. Jenks in 1905, the photograph documents the vicinity of the Octavia Hill Association's housing on League Street. (Courtesy of the Special Collections Research Center, Temple University Libraries.)

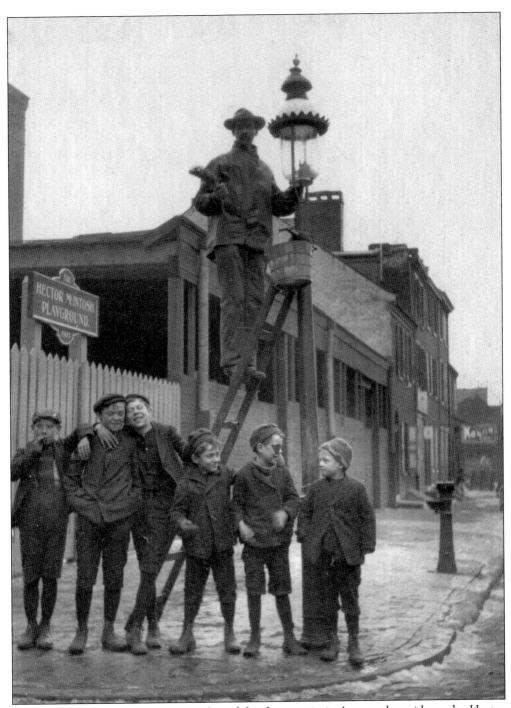

HECTOR MCINTOSH PLAYGROUND. Named for the association's second president, the Hector McIntosh Playground for Small Children was created by the Octavia Hill Association in 1902. According to Jenks's book *Good Housing that Pays*, the association furnished the playground with swings, games, and a sandpile, with an ice-water fountain on the sidewalk. (Courtesy of the Special Collections Research Center, Temple University Libraries.)

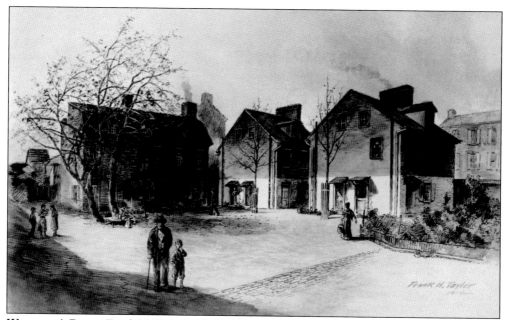

WORKMAN'S PLACE. Frank H. Taylor published this view in his 1914 book, *Ever-Changing Philadelphia*. Workman's Place is a collection of houses that were owned by George Mifflin in the 18th century and, later, became maintained by the Octavia Hill Association. In 1917, Helen C. Jenks described the courtyard of Workman's Place as a "large enclosure shaded by great trees . . . the base of each tree rimmed by a seat." (Courtesy of the Historical Society of Pennsylvania.)

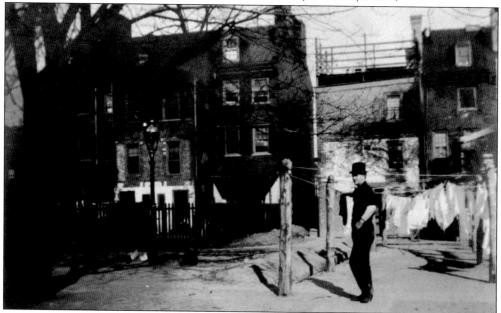

WORKMAN'S PLACE. This photograph was taken in 1909 by Miss M.A. Lynch, whose notations indicate that this view presents the east side of Workman's Place. In this courtyard scene, a man leans against the community's clothesline. Helen C. Jenks writes of the courtyard's "abundant room for clothes-lines, not infringing on the space for the children's play." (Courtesy of the Historical Society of Pennsylvania.)

Six

DICKINSON SQUARE WEST

Dickinson Square West, formerly known as Dickinson Narrows, is bounded on the east by Fourth Street and by Sixth Street on the west. The neighborhood then stretches from Washington Avenue to Mifflin Street. This area was home to a thriving community of Jewish immigrants from the 1880s to the mid-20th century. The sidewalks of South Seventh Street, below Tasker Street, were home to a particularly vibrant marketplace. Beginning in the post–World War II era, a migration took place within South Philadelphia's Jewish community, with most families and congregations moving to Philadelphia's northeastern suburban communities. Today, the Little Shul synagogue's active congregation stands as a reminder of the neighborhood's Jewish history and invites new congregants to join the community's renaissance in South Philadelphia. The most visible reminder of Dickinson Square West's Jewish history is the towering Mount Sinai Hospital building complex. The hospital began as a Jewish medical center in 1905 and served the surrounding South Philadelphia community until it closed in the 1980s. At its height, the hospital was a state-of-the-art facility with impressive architecture and grounds. In 1922, the newly designed wing was described as having "chemical, bacteriological, and pathological laboratories, and a roof garden of unusual attractiveness.

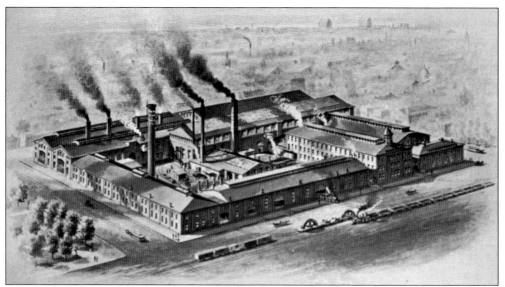

THE SOUTHWARK FOUNDRY AND MACHINE COMPANY. Established in 1836 at Fifth Street and Washington Avenue, the Southwark Foundry manufactured engines, pumps, machine tools, sugar-refining equipment, war materials, and other heavy machinery. After being acquired by the Baldwin Locomotive Works in 1930, the foundry became known as the Baldwin Southwark Corporation. Today, Sacks Playground sits on the site. (Reprinted from *General Catalogue of the Southwark Foundry and Machine Co.*, 1896.)

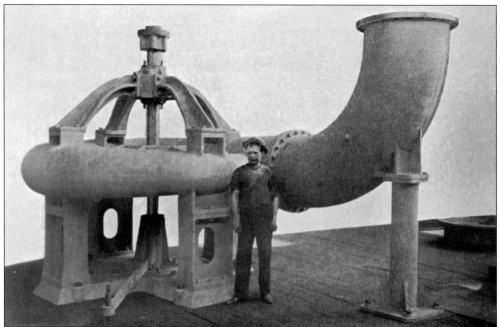

SOUTHWARK CENTRIFUGAL PUMP. The Southwark Foundry manufactured centrifugal pumps for use in dry docks, drainage, irrigation, sewer systems, and other water-handling scenarios. The company boasted of being the first to build this type of pump in large sizes and supplied pumps to a number of federal navy yards, including the League Island Yard in Philadelphia. (Reprinted from *General Catalogue of the Southwark Foundry and Machine Co.*, 1896.)

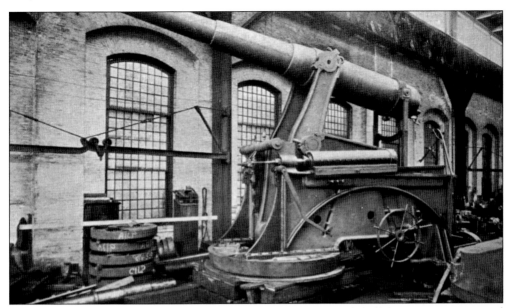

Disappearing Gun Carriage. Southwark Foundry also provided shell-forging equipment and other war materials to the US War Department during World War I. This gun carriage was one of two ordered by the Army for experimentation. (Reprinted from *General Catalogue of the Southwark Foundry and Machine Co.*, 1896.)

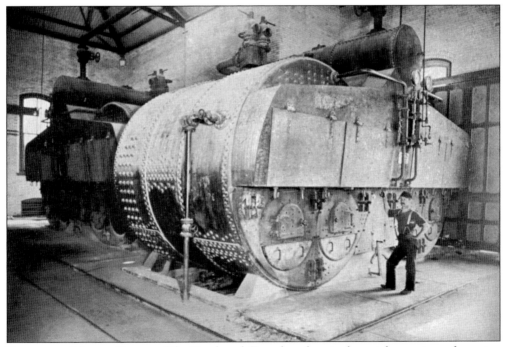

Battery of Marine Boilers. The Southwark Foundry advertised specialty castings of any size, with a weight of up to 100,000 pounds. One example of custom work is this marine boiler for use in ship steam engines. The foundry provided 23 of such boilers in Philadelphia. (Reprinted from *General Catalogue of the Southwark Foundry and Machine Co.*, 1896.)

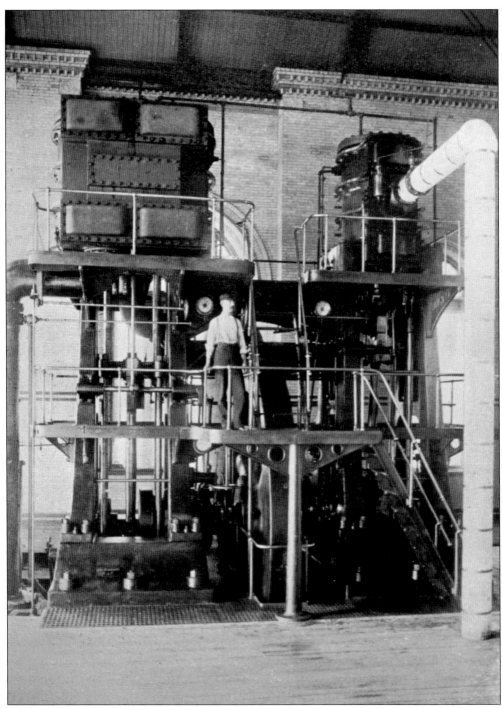

SOUTHWARK COMPOUND CONDENSING CRANK AND FLYWHEEL HIGH-DUTY PUMPING ENGINE. The Southwark Foundry designed and built high-capacity steam-pumping engines for use in waterworks. The facilities allowed for constructing large engines, such as this pump with a capacity of 15 million gallons per day. This pump was specifically designed for use in a waterworks with limited space. (Reprinted from *General Catalogue of the Southwark Foundry and Machine Co.*, 1896.)

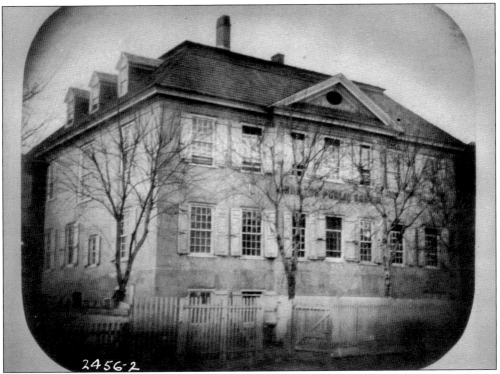

WHARTON SCHOOL. The Wharton School occupied the same ground as Joseph Wharton's Walnut Grove estate that is known for hosting the storied Meschianza pageant. Walnut Grove went on to become a poor children's asylum, a coach factory, and a small schoolhouse before being demolished to make way for the Wharton School. Currently, the Vare-Washington School operates in the same location. (Courtesy of PhillyHistory.)

WASHINGTON GRAMMAR SCHOOL. The southwest corner of Fifth and Federal Streets, below Washington Avenue, has long been home to educational institutions. This image is reprinted from the *46th Annual Report of Controllers*, 1864, and labeled as "Washington Grammar School, Fifth Street, Below Washington." (Reprinted with permission of the Historical Society of Pennsylvania.)

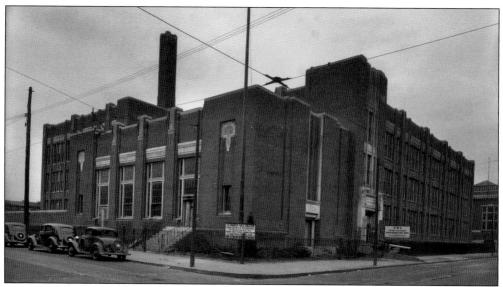

GEORGE WASHINGTON SCHOOL, 1937. The signage in this photograph declares this school as a project of the School District of Philadelphia and the Federal Public Works Administration, which was part of Franklin Delano Roosevelt's New Deal of 1933. The organization was responsible for contracting the construction of large-scale public works, such as community schools. The George Washington School was built in 1937 as part of this effort. (Courtesy of PhillyHistory.)

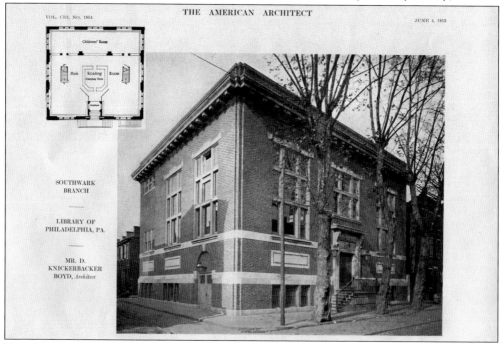

FREE LIBRARY OF PHILADELPHIA, SOUTHWARK BRANCH. The Carnegie Corporation provided funding for this and 24 other Philadelphia library branches. The building was designed by Philadelphia architect David Knickerbacker Boyd, and it opened to the public in 1912. While the Free Library no longer maintains this site, the building still stands at 1108 South Fifth Street. (Reprinted from *The American Architect*.)

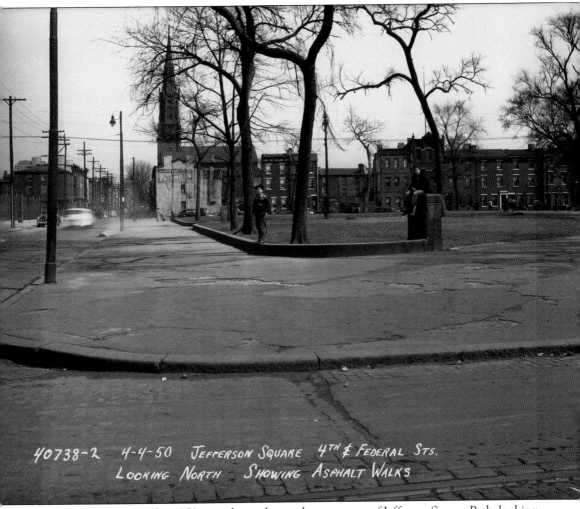

JEFFERSON SQUARE. This 1950 view shows the southwest corner of Jefferson Square Park, looking north from Fourth and Federal Streets. Two boys look outward from the park's granite walls, and Emanuel Lutheran Church is visible in the distance. The park was constructed in the early 19th century, then deeded to the Union army and renamed Camp Jefferson during the Civil War. In the 1870s, the City of Philadelphia refurbished Jefferson Square as a "strolling park." (Courtesy of PhillyHistory.)

St. Alphonsus' Church. Built about 1865 after designs by Napoleon LeBrun, the St. Alphonsus' Church at Fourth and Reed Streets served Southwark's Lithuanian and Polish Catholic communities. (Reprinted from *Diamond Jubilee Memoir of St. Alphonsus' Church, 1853–1928.*)

St. Alphonsus' Church, Sacred Heart Altar. This photograph dates to 1910 and depicts the Sacred Heart Altar at St. Alphonsus. The altar painting depicts the adoration of Jesus by St. Margaret Mary Alacoque. (Reprinted from *Diamond Jubilee Memoir of St. Alphonsus' Church, 1853–1928*.)

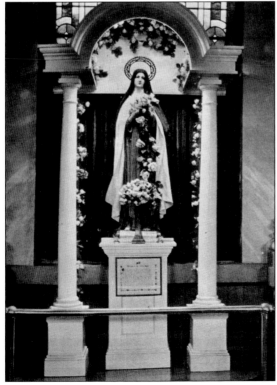

St. Alphonsus' Church, Shrine of the Little Flowers. The Little Flower shrine at St. Alphonsus was unveiled and blessed on June 8, 1925. The shrine honors St. Thérèse of Lisieux. (Reprinted from *Diamond Jubilee Memoir of St. Alphonsus' Church, 1853–1928*.)

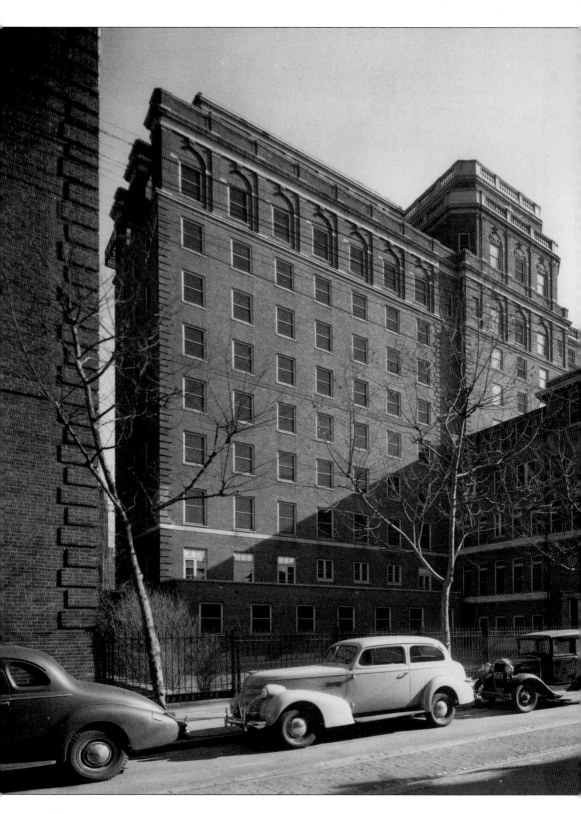

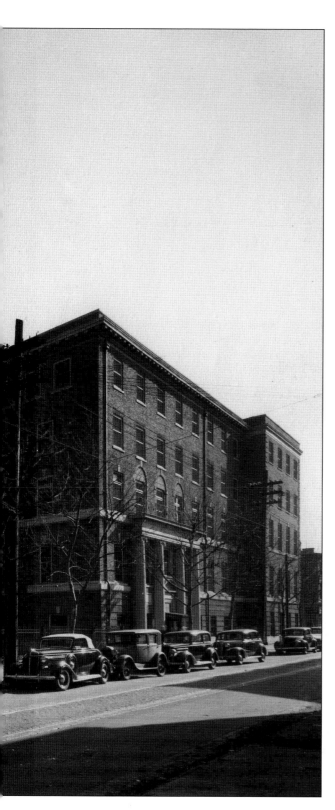

MOUNT SINAI HOSPITAL, 1921–1939.
Between a bustling emergency
ward and overcrowded outpatient
rooms, Mount Sinai was in dire
need of expansion within five years
of opening. The board of directors
commissioned the firm Magaziner,
Eberhard & Harris to design a new
building, and the campus expanded
greatly between 1921 and 1939.
The final addition to the hospital
came in the 1980s. (Courtesy of
the Atheneum of Philadelphia.)

MOUNT SINAI HOSPITAL, EXTERIOR. Mount Sinai Hospital opened in 1905, following the efforts of the Mount Sinai Hospital Association and its president Jacob Lit, also known for his popular department store Lit Brothers. With the purchase of an old furniture factory, the association built the modest hospital at Fifth and Wilder Streets to serve the burgeoning immigrant population of Southwark. It was the only hospital in the area, serving a population of over 100,000. (Reprinted from the 1906 pamphlet.)

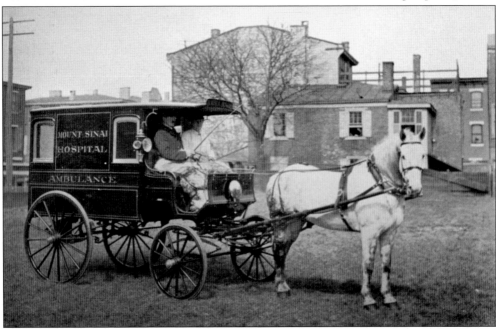

MOUNT SINAI HOSPITAL, AMBULANCE. Mount Sinai offered an ambulance service beginning in 1906. The hospital's emergency ward was very active, serving nearly 500 cases a month in its earliest years. Many of these emergency cases came from the nearby riverfront industries that the hospital served. (Courtesy of the Special Collections Research Center, Temple University Libraries.)

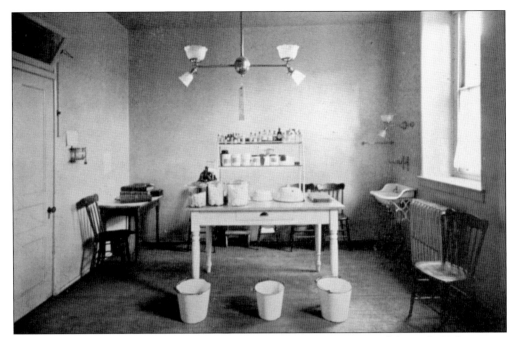

MOUNT SINAI HOSPITAL, SURGICAL CLINIC. Surgical operating rooms of the early 20th century were beginning to take on the appearance of modern medical facilities. In this photograph, the surgical table has been prepped, complete with cotton swabs and medical instruments. (Courtesy of the Special Collections Research Center, Temple University Libraries.)

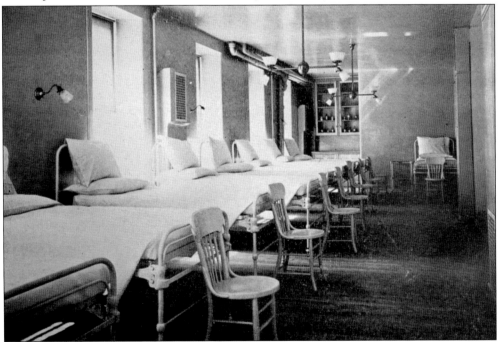

MOUNT SINAI HOSPITAL, MEN'S WARD. This photograph represents the men's ward of the original hospital. The hospital wards were overcrowded from the institution's earliest years until its expansion. (Courtesy of the Special Collections Research Center, Temple University Libraries.)

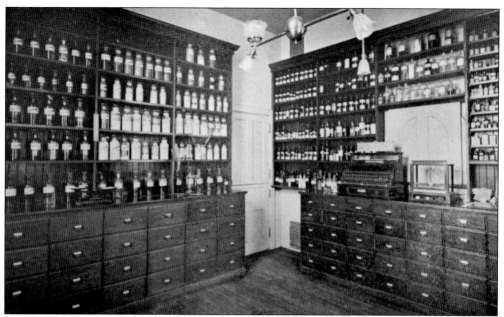

MOUNT SINAI HOSPITAL, PHARMACY. Mount Sinai ran a pharmacy on the premises. As many of the patients were poor, the dispensaries often provided medication free of charge. Donations from the board, members, and the general community made up a small portion of the hospital's funding, while Pres. Jacob Lit raised the majority of the finances on his own. (Courtesy of the Special Collections Research Center, Temple University Libraries.)

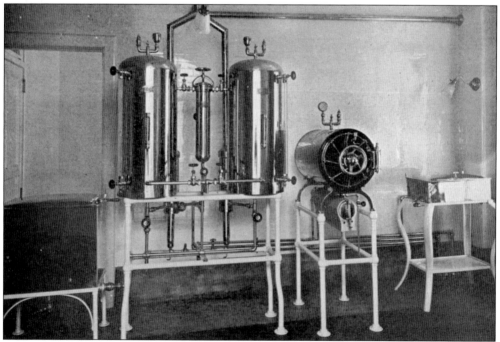

MOUNT SINAI HOSPITAL, STERILIZING ROOM AND APPARATUS. This photograph provides a view of the hospital's brass sterilizing equipment. (Courtesy of the Special Collections Research Center, Temple University Libraries.)

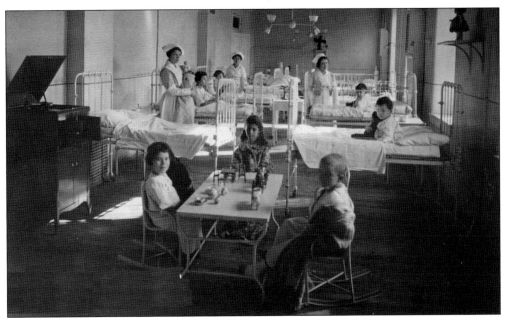

MOUNT SINAI HOSPITAL, CHILDREN'S WARD. The children's ward of Mount Sinai Hospital is shown here. (Courtesy of the Special Collections Research Center, Temple University Libraries.)

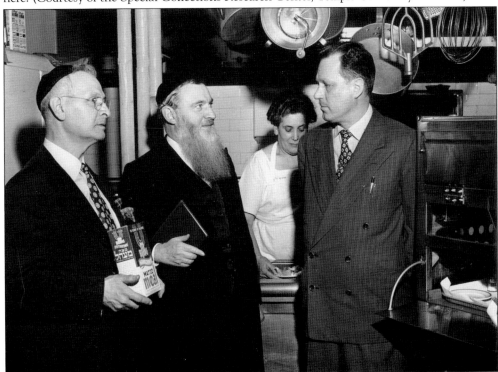

MOUNT SINAI HOSPITAL, KITCHEN. In this image, a rabbi inspects Mount Sinai's kosher kitchen. While open to all, the hospital was built to serve a largely Jewish immigrant population of Southwark. Kosher meals were a necessity for many of the patients. (Courtesy of the Special Collections Research Center, Temple University Libraries.)

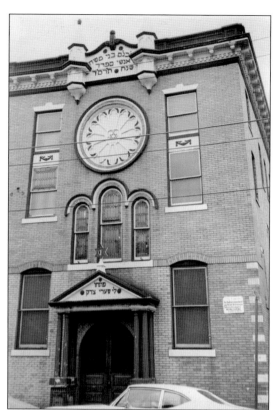

B'NAI MOSHE SYNAGOGUE. Founded in 1904 at Fifth and Watkins Streets, the B'nai Moshe synagogue served a congregation of over 200. B'nai Moshe presented a bold exterior, with its prominent rose window, trio of arched windows, elaborate molding and cornice carving, and Hebrew lettering. (Photograph by Marc Toplin, 1975, courtesy of the Special Collections Research Center, Temple University Libraries.)

ANSHAI ZITOMAN SYNAGOGUE. This congregation at Sixth and Dickinson Streets was one of numerous neighborhood synagogues in South Philadelphia. In *The Jewish Community of South Philadelphia*, author Allen Meyers estimates that there were over 150 synagogues in South Philadelphia during the community's heyday. The Calvary African Methodist Episcopal Church later purchased the building. (Photograph by Marc Toplin, courtesy of the Special Collections Research Center, Temple University Libraries.)

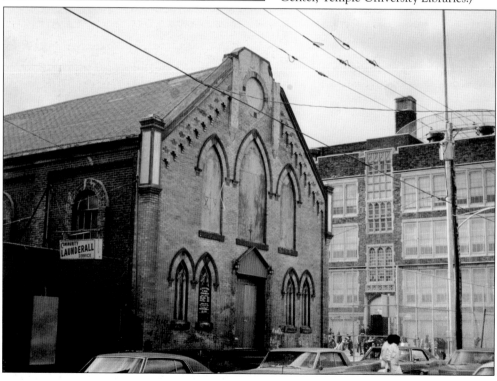

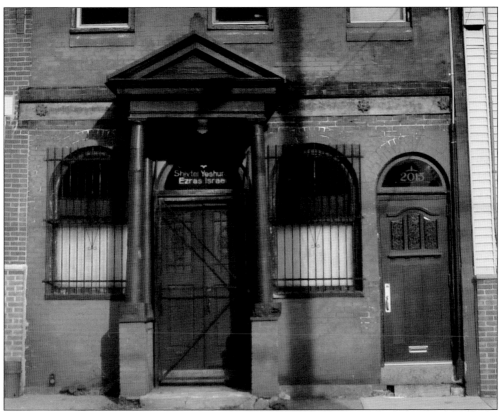

LITTLE SHUL SYNAGOGUE, EXTERIOR.
The Little Shul at 2015 South
Fourth Street looks much like the
surrounding South Philadelphia row
houses, but the distinctive pillared
entrance designates it as a house
of worship. Congregation Shivtei
Yeshuron Ezras Israel was founded
in 1876 and chartered in 1892. The
congregation moved to this location
in 1909. (Courtesy of Joel Spivak.)

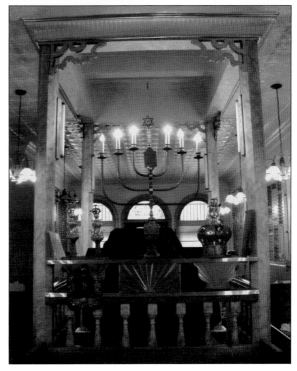

LITTLE SHUL SYNAGOGUE, INTERIOR.
The Little Shul's interior has
become a repository for Hebrew
artifacts of Southwark's Jewish
community. The Shul's walls are
covered in tin and adorned with
tapestries. This photograph shows
the ark that holds the congregation's
Torahs. (Courtesy of Joel Spivak.)

JEWISH EDUCATION CENTER. This photograph depicts the kindergarten class at the Jewish Education Center at 508 Moore Street about 1940. This was a summer training program of the Hebrew Sunday School Society of Philadelphia. The building had formerly been used as a Catholic retirement home for the Our Lady of Good Counsel Church. (Courtesy of the Special Collections Research Center, Temple University Libraries.)

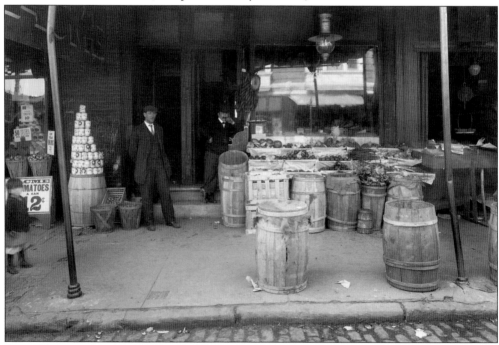

ACME MARKET. One block west of today's Dickinson Square West boundary, the Jewish business district on South Seventh Street, below Tasker Street, bustled with shoppers in the early 20th century. This Acme Market stood among many smaller storefronts added to the homes of small business owners. One shopkeeper stands beside a towering display of canned fish, while the other leans against the cast-iron cash register. (Courtesy of Joel Spivak.)

Seven

WESTWARD TO PASSYUNK

In 19th-century maps of the old Southwark District, Passyunk Road (now Passyunk Avenue) can be traced as the district's western border. Today, the blocks between Dickinson Square West and Passyunk Avenue are included in the East Passyunk Crossing and East Passyunk Square neighborhoods. Throughout the 20th century, these streets were home to a diverse population of Italian Catholic, Irish Protestant, Russian Jewish, and African American families. Two institutions commemorate Southwark by name: the Southwark Station Post Office and the Southwark School. Although no photograph is included in this book, the Southwark Station Post Office is historically and artistically significant. Built in 1923, the post office's interior includes murals painted as part of the New Deal effort to employ artists. The Southwark School, with its castle-like appearance, was built in 1910 and continues to serve as an elementary school.

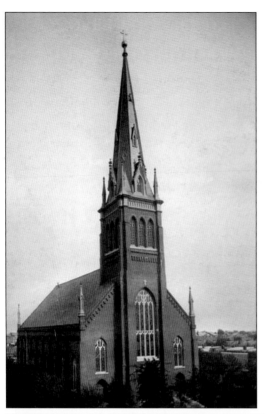

ANNUNCIATION OF THE BLESSED VIRGIN MARY CHURCH. This church was constructed in 1963. The original building included a towering spire, as seen in this 1871 photograph. The spire was damaged and removed in the 1930s. The congregation is still active, and the church still stands across the street from the Southwark Station Post Office at Tenth and Dickinson Streets. (Courtesy of Tom Madorna.)

ANNUNCIATION PAROCHIAL SCHOOL GRADUATION. In 1948, Annunciation purchased the James Wilson public school at Twelfth and Wharton Streets. During the postwar baby boom years, the classrooms were filled with as many as 60 students per class. Posing on the church steps are graduates of the eighth grade class of 1973. The Reverend Arthur P. Di Giacomo sits in the front row. (Courtesy of Tom Madorna.)

ATCO Door & Sash, c. 1940. Arthur Tofani's millwork company was built on the 1400 block of South Eighth Street around 1900 and specialized in the manufacture of windows and doors. On July 4, 1937, the factory burned after being hit by fireworks. In this image, Liberata Tofani (second from right) stands with the workers in front of the rebuilt factory. The business continued at this location into the 1980s. Typically, such buildings have become auto repair shops or, as in this case, converted into residences. (Courtesy of Arthur Tofani III, with thanks to Francis W. Hoeber and Ditta Baron Hoeber.)

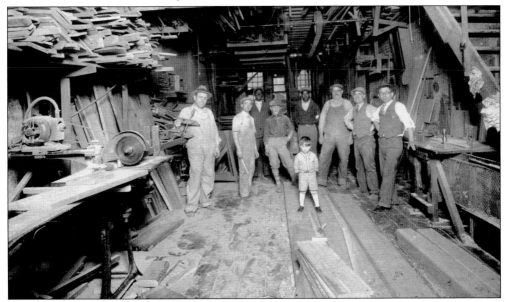

Interior View of the ATCO Door & Sash Woodshop, c. 1929. The Tofani woodshop machinery ran off a central engine and belt drive, seen in this interior view of the shop. The Tofani family lived on the premises, and the young Arthur Tofani Jr. stands front and center among the workers. Arthur Tofani Sr. appears on the right. The styles of wooden doors made here are still ubiquitous in the neighborhood. (Courtesy of Arthur Tofani III, with thanks to Frances and Ditta Baron Hoeber.)

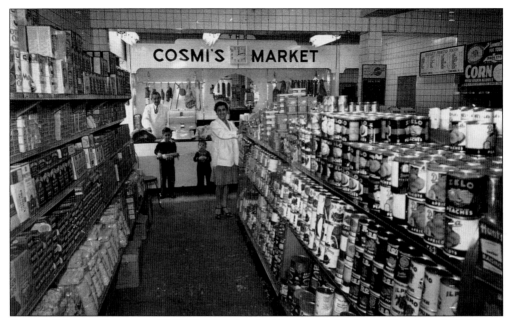

COSMI'S MARKET INTERIOR, 1947. Seen posing inside Cosmi's Market at Eighth and Dickinson Streets are, from left to right, Cosmi Quattrone, Leon and Ray Seccia, and Pauline Quattrone. Cosmi's Market opened in 1932 as a grocery and butcher shop. In 1976, Leon took over the business, which is currently run by his son Mike Seccia. (Courtesy of Cosmi's Deli.)

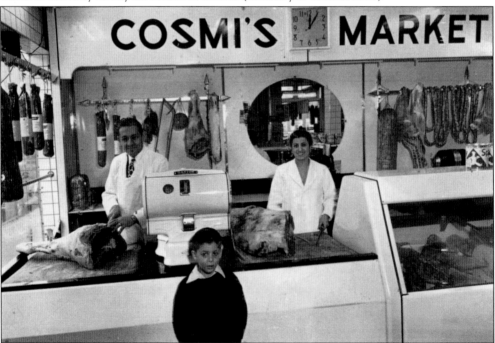

COSMI, LEON, AND PAULINE IN COSMI'S IN 1947. Cosmi's originally operated as a neighborhood grocer and butcher shop. A fire next door forced the shop to close at a time when large grocery chains were becoming prominent. Since Cosmi's was already known for its award-winning hoagies, Leon decided to reopen it as a delicatessen. (Courtesy of Cosmi's Deli.)

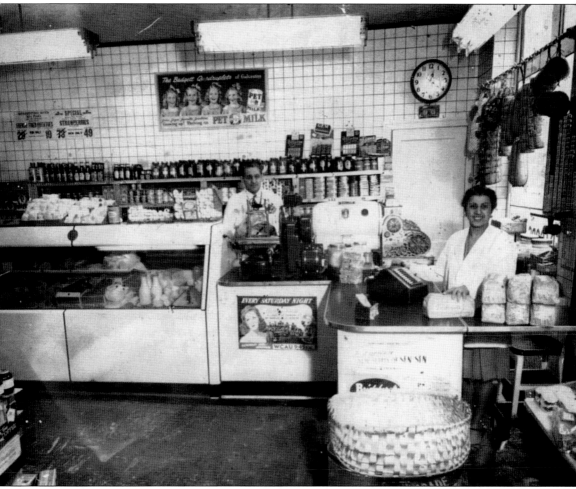

COSMI AND PAULINE AT THE COUNTER OF COSMI'S MARKET. These publicity photographs showcase the bountiful array of products sold at Cosmi's. Pauline beams from behind the cash register while Cosmi stands ready at the slicer. The shop was fully stocked with an array of cheeses, meats, dairy, pickles, and canned goods. (Courtesy of Cosmi's Deli.)

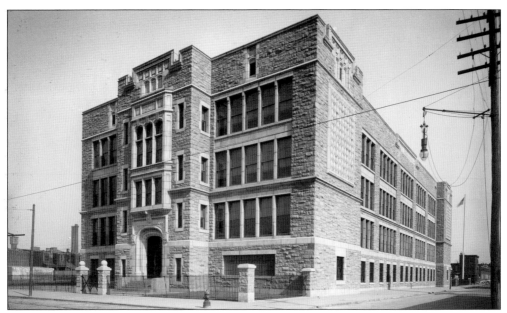

SOUTHWARK ELEMENTARY SCHOOL. The Southwark Elementary School was built at Eighth and Mifflin Streets in 1910. Like many buildings of its period, the school was designed in the Late Gothic Revival style. The school continues to serve the neighborhood's diverse population today. (Courtesy of PhillyHistory.)

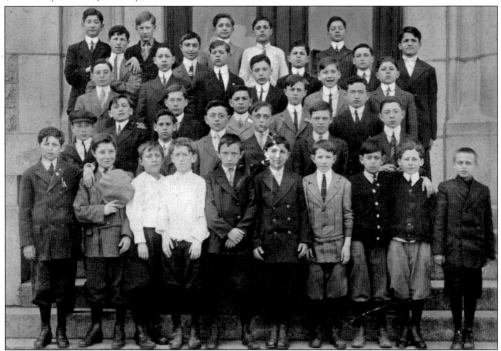

CLASS IN SOUTHWARK SCHOOL DOORWAY. A class of schoolboys poses on the front steps of the Southwark Elementary School in this c. 1912 photograph. The carved Gothic wooden doors offer an impressive backdrop to this class picture. (Courtesy of the Special Collections Research Center, Temple University Libraries.)

SOUTHWARK ELEMENTARY SCHOOL ANNUAL CLOTHING DRIVE. This image was published in the *Philadelphia Evening Bulletin* on December 5, 1960, with the headline "Pupils bring bundles of clothing for Goodwill Industries to the Southwark Public School." The bags carried by each boy are illustrated with a cartoon drawing of a mother pushing her son in a wheelchair, along with the slogan "Give Goodwill a Push." (Courtesy of the Special Collections Research Center, Temple University Libraries.)

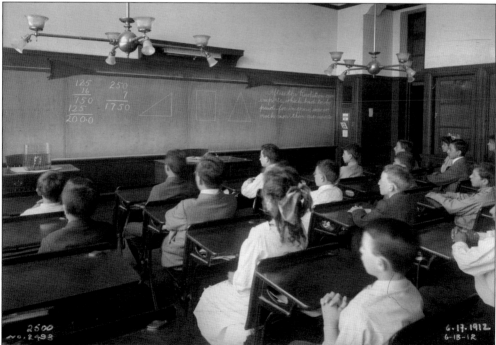

SOUTHWARK ELEMENTARY SCHOOL STUDENTS. Dated June 17, 1912, this photograph depicts a geometry class at Southwark Elementary. The students, both boys and girls, are either very well behaved or posing for the photograph. The school was electrified, as evidenced by the brass overhead lighting fixtures with glass shades. (Courtesy of PhillyHistory.)

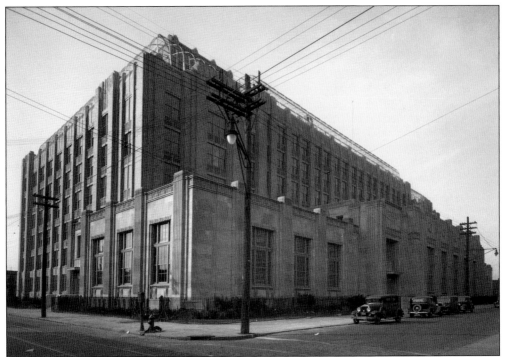

Bok Vocational School. The Edward Bok Vocational High School was built in 1937–1938 at 1901 South Ninth Street. The architect, Irwin T. Catharine, designed the building in the period's fashionable Art Deco style. The school's namesake was the longtime editor of *Ladies' Home Journal* and the husband of Mary Louise Curtis, who funded the Settlement Music School's building. (Courtesy of PhillyHistory.)

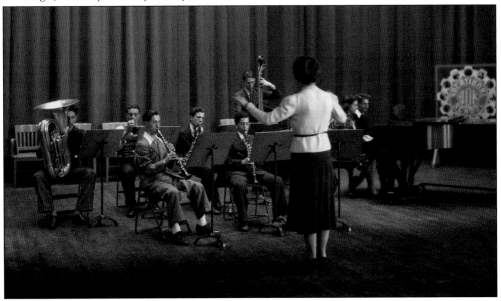

Bok Vocational School Musical Performance. The banner behind the piano in this vintage photograph reads "Bok Vocational School." The ensemble consists of brass, woodwinds, strings, and two pianists. (Courtesy of PhillyHistory.)

STUDENT PROJECTS AT BOK VOCATIONAL SCHOOL. The two girls in this image, dated June 23, 1952, gesture toward their housing model projects. The girl closest to the window displays a suburban neighborhood, while the other girl presents an urban environment. (Courtesy of the Special Collections Research Center, Temple University Libraries.)

CITY PLANNING PROJECTS AT BOK VOCATIONAL SCHOOL. Taken on the same date as the previous image, this photograph shows a larger group examining city planning models. The students seem to be comparing a model that resembles a "strolling park," like Jefferson Square, with a recreational sports park. (Courtesy of the Special Collections Research Center, Temple University Libraries.)

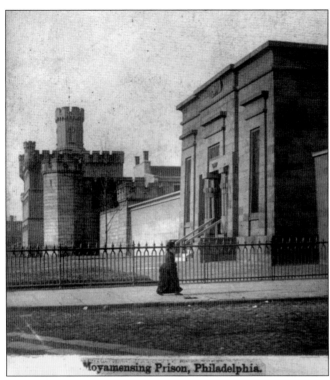

Moyamensing Prison, Philadelphia.

MOYAMENSING PRISON, c. 1896. Located along the outskirts of Southwark at Passyunk and Reed Streets, Moyamensing Prison was built between 1832 and 1835. Thomas Ustick Walter designed the building with crenellated rooftop battlements and towers resembling a castle. In 1849, Edgar Allan Poe wrote of being incarcerated one evening at Moyamensing Prison for public drunkenness. (Courtesy of the Library of Congress.)

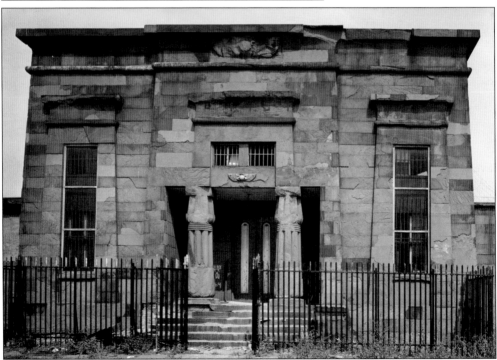

MOYAMENSING PRISON, DEBTORS' WING. This Egyptian Revival structure was built to house debtors. When penal code changes ended the imprisonment of debtors, the wing was used to house female prisoners. (Courtesy of the Library of Congress.)

Eight

PENNSPORT

Perhaps more than in any other neighborhood in old Southwark, many Pennsport families have lived in the same neighborhood for generations. Pennsport meets Queen Village to the north and Snyder Avenue to the South and extends from the Delaware River to South Fourth Street. Just as Queen Village suffered significant architectural losses when Interstate 95 was constructed, Pennsport lost hundreds of homes and was likewise cut off from the river. Current efforts to reestablish ties to the river include the new Pier 53 and Pier 68 parks as well as a more pedestrian friendly street connector at Tasker Street. Pennsport is experiencing a renaissance in terms of neighborhood commerce and new construction. Recently, the authors overheard a man on his cell phone talking about these changes, saying, "I'm walking through the old neighborhood and it's totally different. You wouldn't believe it." Along with recent changes, Pennsport has much tradition that has remained. The most visible and celebrated tradition is that of the Mummers. Every New Year's Day, the jubilant Mummers Parade marches up Broad Street with music, costumes, dancing, and revelry. At the end of the day, the Mummers clubs return to Pennsport in a parade down South Second Street, known to many as "Two Street." In a celebration akin to the Mardi Gras parade in New Orleans, the streets become a raucous festival where anything goes. The Mummers Parade comes just once a year, but a celebratory spirit pervades Pennsport's streets year-round.

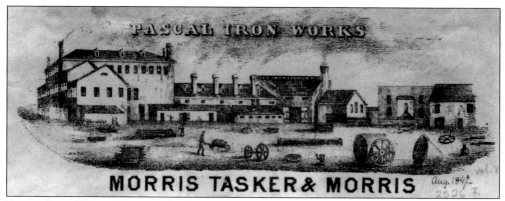

PASCAL IRON WORKS. In 1836, the firm of Morris, Tasker & Morris opened Pascal Iron Works on Fifth Street, below Franklin Street (now Tasker). The firm manufactured a variety of ironwork, including stoves, grates, tools, and machine parts for sugar refineries. In 1856, the firm became Morris, Tasker & Co. The stockyard between Fourth and Moyamensing Streets later became Dickinson Square Park. (Courtesy of the Library Company.)

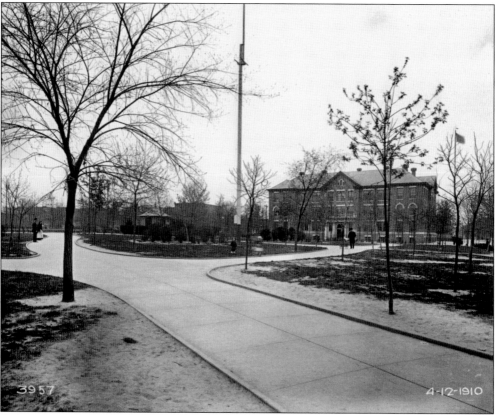

DICKINSON SQUARE PARK, 1910. Named after Gov. John Dickinson (1732–1808), Dickinson Square Park opened to the public on October 27, 1900, to great fanfare. The event, described in the paper as "one of the greatest celebrations in the southern section of the city," featured an opening prayer and hundreds of local schoolchildren singing patriotic songs. This image was taken 10 years after the park's opening. (Courtesy of the City of Philadelphia.)

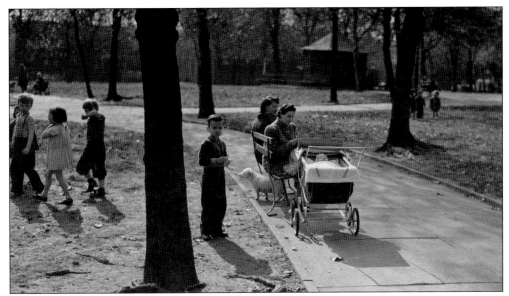

DICKINSON SQUARE PARK, 1950s. For over a century, children and adults alike have enjoyed walking dogs and strolling along Dickinson Square Park's paths that wind beneath a canopy of trees. In 2012, the park experienced a rebirth after a large renovation project. During the summer months, the park regularly hosts a neighborhood farmers' market, outdoor films, and other public events. (Courtesy of the Special Collections Research Center, Temple University Libraries.)

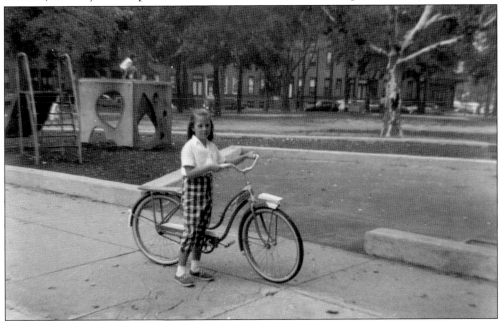

DICKINSON SQUARE PARK, APRIL 1958. Dickinson Square Park offers neighborhood children an open-space alternative to sidewalk and street play. The earliest efforts to develop the former Pascal Iron Works plot were spearheaded by a playground advocacy organization, and to this day, one of the park's most popular features is an impressive array of playground equipment. In this image, a young girl is seen in front of a piece of equipment known to the children as the "cheese house." (Courtesy of Trudy Vollbrecht Smith.)

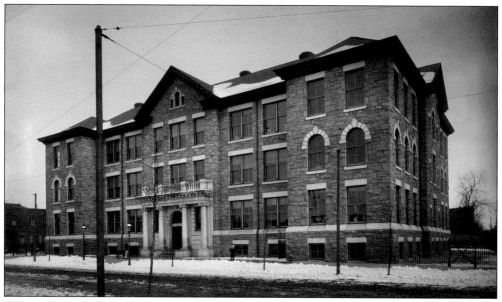

ABIGAIL VARE SCHOOL. Named for the mother of the politically influential Vare brothers, the Abigail Vare Elementary School was formally dedicated at Third and Morris Streets in September 1904. At that time, the Abigail Vare Methodist Episcopal Church was located across Morris Street from the school. The church was demolished early in the 20th century. No longer used by the Philadelphia School District and vacant since 2013, Abigail Vare School still maintains a grand presence across from Dickinson Square Park. (Courtesy of PhillyHistory.)

ABIGAIL VARE SCHOOL STUDENT. A 1904 news clipping describes the Vare School as "the handsomest and, through the generosity of the Vare brothers, the best equipped school downtown." Throughout the years, Abigail Vare School livened the nearby streets on weekday mornings and afternoons with schoolchildren coming and going. After school, many children would hurry across the street to play in Dickinson Square Park. (Courtesy of Elaine Righter.)

Pony Ride. The old Southwark District offered a number of fun activities for children in the 1930s, 1940s, and 1950s. Residents from those days fondly recall pony rides as well as traveling carnival attractions, such as the Ferris wheel, merry-go-round, and the Whip. In this 1954 photograph, young Tom Oxenford enjoys his first pony ride on Fernon Street. The man at right is unidentified. (Courtesy of Marie Oxenford Hicks.)

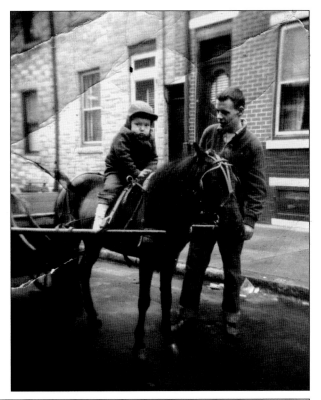

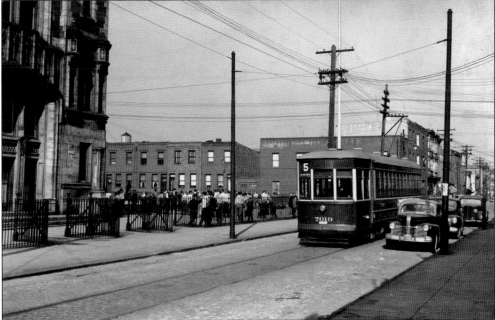

Horace Howard Furness High School. A gathering of high school boys stands outside the Furness High School in this c. 1950 photograph. The school was built in 1914 and named for the distinguished Shakespearean scholar and brother of architect Frank Furness. The Route 5 trolley is seen running southbound on Second Street. (Courtesy of PhillyHistory.)

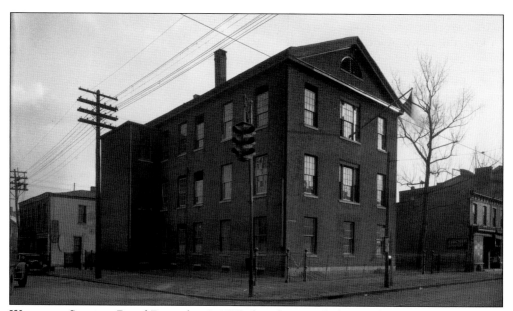

WECCACOE SCHOOL. Dated December 9, 1935, this photograph depicts the Weccacoe School on Second Street, just below Reed Street. Originally known as the Reed Street School, the schoolhouse was built in 1836 and became known as the Weccacoe School in 1848. The neighboring building on Reed Street was the auto body shop of Chas. L. Gable Co., and the house next door on Second Street advertises "Chicken Dinner." (Courtesy of PhillyHistory.)

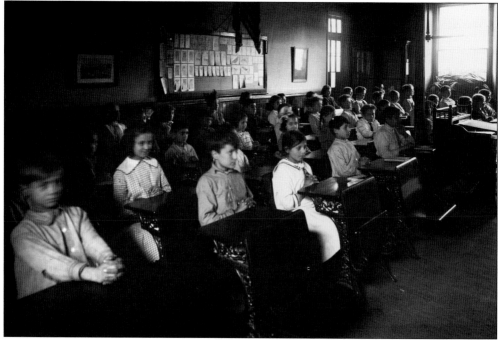

WECCACOE SCHOOL CLASSROOM. The elementary students of the Weccacoe School are shown here on December 10, 1914. The student body of young boys and girls sits at desks of cast iron and wood, with folding seats, arranged neatly in rows. Behind the students, a pair of American flags hangs from the bulletin board. (Courtesy of PhillyHistory.)

GREENWICH PRESBYTERIAN CHURCH.
In 1865, this church was erected on Greenwich Street, just east of Moyamensing Avenue. A number of improvements were made in 1880. The building was expanded, and a beautiful Gothic front was erected. Towers were constructed on the east and west, with the western spire reaching 100 feet. On the south side, an entrance was made from Tasker Street. In 1987, the church became home to the Khmer Palelai Buddhist Temple. The Khmer Palelai lined the property with a brightly painted cement fence topped with Buddhist statues, through which passersby could occasionally hear chanting. The temple relocated in 2013, and the building was sold and demolished shortly thereafter. (Reprinted from *The Presbyterian Church in Philadelphia* by Rev. William P. White and William H. Scott, 1895.)

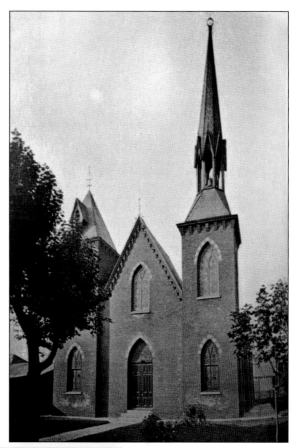

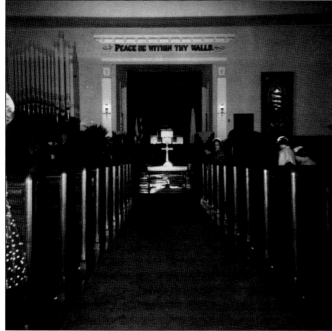

GREENWICH PRESBYTERIAN CHURCH, INTERIOR, 1950s. This image provides a view of the church's altar and lettering above: "Peace Be Within Thy Walls." (Courtesy of Trudy Vollbrecht Smith.)

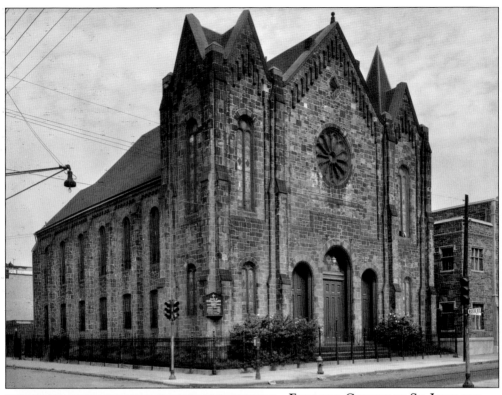

EPISCOPAL CHURCH OF ST. JOHN THE EVANGELIST. St. John's was built in 1867 at 1332 South Third Street. The congregation hosted a number of social-service organizations, including a notable food-service mission. The church combined parishes with Emanuel Lutheran Church in 2008, when the Lutheran church was forced to close its doors. St. John's eventually met the same fate, and the last service was held on December 31, 2012. The church and parish hall were demolished in 2013. (Courtesy of PhillyHistory.)

MOTHER AND CHILD IN FRONT OF ST. JOHN'S. John Frank Keith photographed this young mother holding her baby in the 1940s, presumably on the occasion of the baby's baptism. The handsome cast-iron fence surrounding the church can be seen in the background. (Courtesy of the Library Company.)

Tom Thumb Wedding. Another popular amusement for the young members of St. John's was the Tom Thumb wedding. These miniature weddings were inspired by the 1863 nuptials of Charles Stratton and Lavinia Warren. Stratton (also known as Gen. Tom Thumb), who stood at approximately 2.5 feet tall as an adult, was a sensationally popular performer with P.T. Barnum in the 1800s. Tom Thumb weddings were popular church performances and fundraisers throughout the 1950s. (Courtesy of Elaine Righter.)

Cowboy Joe Performance. The children of St. John's enjoyed pageantry, in addition to the Sunday school curriculum. This 1950s photograph features two young performers from a group performance of "Ragtime Cowboy Joe." The song was written in 1912 and popularly performed by various artists in the 1940s and 1950s, including Lucille Ball on an episode of *I Love Lucy.* (Courtesy of Elaine Righter.)

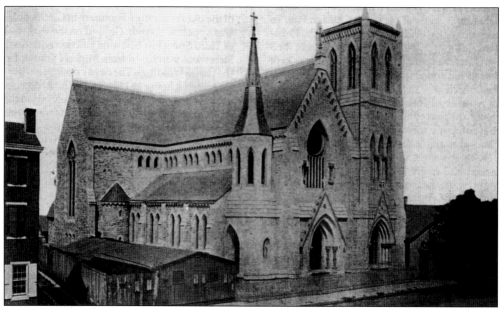

SACRED HEART OF JESUS CHURCH. Sacred Heart Parish separated from St. Philip Neri's congregation in 1871. Initially, a small chapel was erected on the west side of Third Street, just below Reed Street. Ground was broken just south of the chapel in 1872 for the permanent church. Completed in 1876, the stone church was said to be one of the most beautiful Gothic buildings in the diocese. (Reprinted from *Sacred Heart of Jesus Parish 125th Anniversary*.)

GRADUATION AT SACRED HEART CHURCH. The Sacred Heart Parochial School was built on the northeast corner of Reed Street and Moyamensing Avenue in 1892. With 12 classrooms and a large parish hall, the school could accommodate over 700 children. Each year, the parochial school's seniors would pose on the steps of Sacred Heart to commemorate their graduation. (Courtesy of Elizabeth Aros.)

St. Casimir's Church. In 1893, St. Casimir's opened its doors at 324 Wharton Street to serve South Philadelphia's Lithuanian Catholics. The church's adjacent parochial school opened in 1906 and remained active for 100 years before closing its doors. In 2011, St. Andrew's Parish of Fairmount joined St. Casimir's and began holding services in a new home. (Reprinted from *1893–1918 Commemoration of the 25th Anniversary of St. Casimir's Parish*, 1918.)

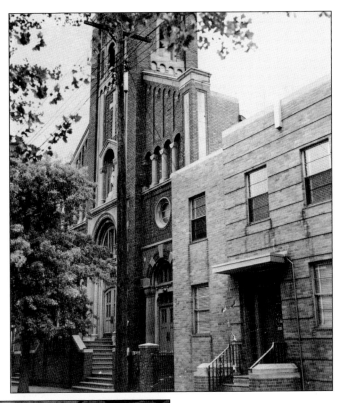

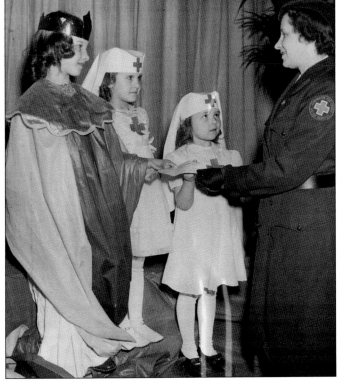

Girls at St. Casimir's Church. This photograph accompanies an article published by the *Philadelphia Evening Bulletin* on February 17, 1942. The caption states, "Lithuanian children, dressed in native costume and as Red Cross nurses, celebrate the 24th anniversary of the independence of their country by presenting contributions totaling $380.50 to the Red Cross Fund in St. Casimir's Church auditorium." (Courtesy of the Special Collections Research Center, Temple University Libraries.)

MUMMERS MUSEUM. With its theatrical Art Deco facade, the Mummers Museum at the intersection of "Two Street" and Washington Avenue is hard to miss. This colorful museum's opening coincided with the US bicentennial celebration in 1976. The museum houses a rich collection of memorabilia and costumes relating to the annual Philadelphia Mummers Parade. In 1901, Philadelphia held the first official Mummers Parade, a tradition that continues to this day. There is much fanfare as the parade winds down Two Street (South Second), where many of the Mummers clubs are located. (Courtesy of the Special Collections Research Center, Temple University Libraries.)

MUMMERS PARADE. The folk custom of mumming took many different forms in various regions of medieval Europe, but most involved an element of masquerade. Mummers Plays in England and Ireland were costumed folk performances that typically took place around Christmas. Swedish, English, Irish, and Germanic settlers brought their mummer traditions to Southwark throughout the 17th, 18th, and 19th centuries. This mid-20th-century photograph shows Joe Walters, captain of the Jokers Club on Two Street. (Courtesy of Elaine Righter.)

MUMMERS PARADE ON TWO STREET. In the 19th century, costumed masqueraders paraded through the streets between Christmas and New Year's Day, firing guns and reciting rhymes in celebration. The Mummers Parade developed into a competitive parade, with the New Years Association Club performing elaborate costumed musical numbers and comical skits. This photograph highlights Ed Farmer in his first prizewinning captain's costume, in 1976. (Courtesy of the Special Collections Research Center, Temple University Libraries.)

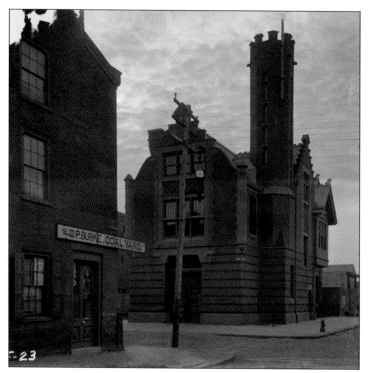

ENGINE 46. This striking historic firehouse was built in 1894–1895 at the corner of Reed and Otsego (Water) Streets. The redbrick building was designed in the Flemish Renaissance Revival style with an elaborate stepped gable. The tower design incorporates crenellations at the top, evoking European castles. The engine house was strategically located to attend to blazes generated by the many industrial complexes on the Delaware waterfront. (Courtesy of PhillyHistory.)

CHASE BAG CO. Plentiful employment in factories along the waterfront allowed Southwark residents without automobiles to easily get to and from their place of work. This scene shows workers of the Chase Bag Co. at Dickinson Street and Delaware Avenue. Pictured to the left, wearing a cap, is Anthony Balkonis who lived a few blocks away at Second and Tasker Streets. (Courtesy of Thomas McGinnis.)

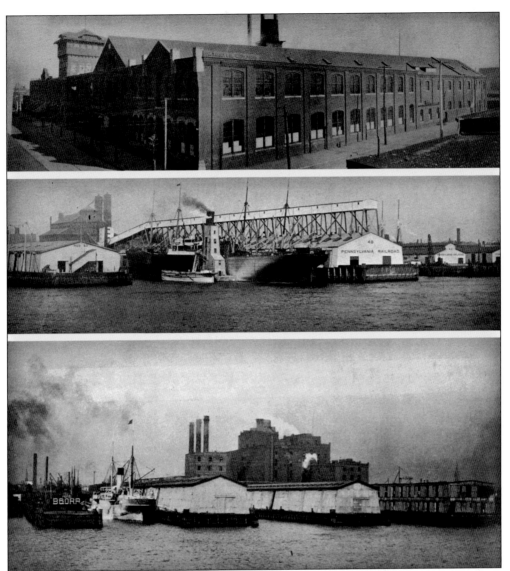

INDUSTRIAL SCENES. Moses King published these three panoramas in 1900. The top photograph shows the building of John T. Bailey & Co., Manufacturers of Bags, Rope & Twine, on Water and Morris Streets. King notes that the company was an outgrowth of a small factory started in 1857 by John T. Bailey, and it became the largest works of its kind in the United States. At center is an image of the grain wharves at Washington Avenue, which were owned by the Girard Point Storage Co. King remarks that the grain elevator was fireproof and made of brick, with a capacity of 450,000 bushels. The bottom image depicts the sugar wharves at Reed on the Delaware River, primarily operated by the American Sugar Refinery (later Domino Sugar). (Reprinted from *King's Views of Philadelphia*, courtesy of the University of Pennsylvania Archives.)

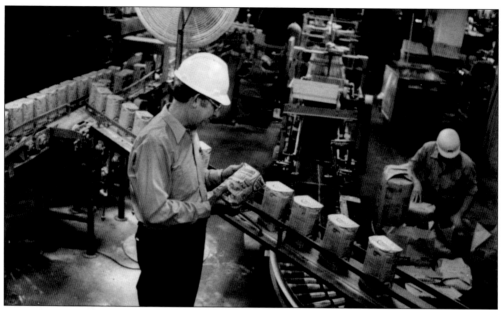

Domino Sugar Manager. In this 1978 photograph, Armando Abay, manager of the Domino Sugar refinery, quality checks five-pound packages bound for the supermarket. Owned by the American Sugar Refinery, the Domino refinery was formed by the former refineries of Harrison, Frazier & Co., E.C. Knight & Co., Claus Spreckels, and W.J. McCahan. (Courtesy of the Special Collections Research Center, Temple University Libraries.)

Unloading Domino Sugar. Clamshell buckets unload raw sugar from floating cranes in this 1978 photograph. In 1900, Moses King eloquently wrote the following regarding Philadelphia's sugar wharves at Reed Street on the Delaware River: "No view of the Delaware River front of Philadelphia is so familiar as the huge group of brick sugar refineries, which picturesquely break up the sky line." (Courtesy of the Special Collections Research Center, Temple University Libraries.)

PUBLICKER COOPERAGE Co. In this photograph taken in the early 1900s, Harry Publicker stands with representatives of the Publicker Cooperage Co. at the Tasker Street Wharf. In addition to the barrel business, Publicker was known to sell the remaining gallons of whiskey he had "sweat" from the used barrels. Publicker went on to found Publicker Industries, a massive commercial alcohol business that employed many residents of Southwark. (Courtesy of Clifford B. Cohn.)

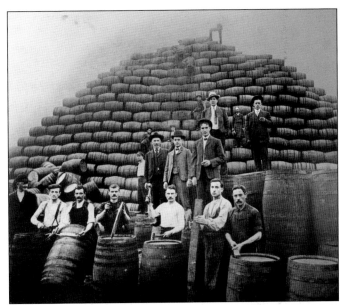

PUBLICKER INDUSTRIES' SNYDER AVENUE DISTILLERY. Following the repeal of Prohibition, Publicker reconstructed its existing distillery at Snyder and Swanson Streets in this towering building. Fully completed in 1934, this location housed the Continental Distilling subsidiary that produced whiskey, gin, rum, and other drinking alcohols. (Courtesy of the Special Collections Research Center, Temple University Libraries.)

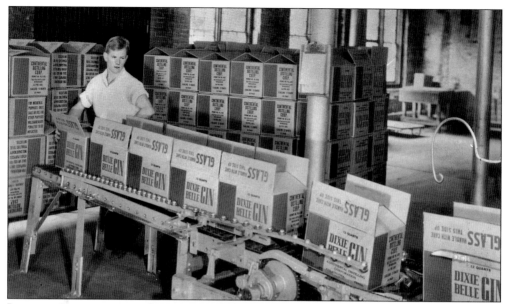

LOADING BOXES ON THE CONVEYOR. Publicker Industries' Continental Distilling division manufactured not only whiskey but also gin and other liquors. In this photograph, a worker in the Snyder Avenue bottling plant prepares boxes to be loaded with company's most popular gin, Dixie Belle. In 1934, Dixie Belle Gin sold for $1.24 per quart. (Courtesy of the Special Collections Research Center, Temple University Libraries.)

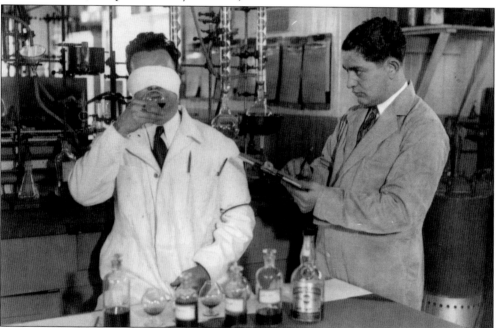

BLIND TASTE TEST AT PUBLICKER. In this 1938 image, two Publicker chemists taste-test aged whiskey at the Snyder Avenue distillery. The sudden demand for whiskey following Prohibition led the company to seek shortcuts in the aging process. Publicker chemist Dr. Carl Haner claimed to have developed a chemical aging process that produced 17-year-old whiskey in only 24 hours. (Courtesy of the Special Collections Research Center, Temple University Libraries.)

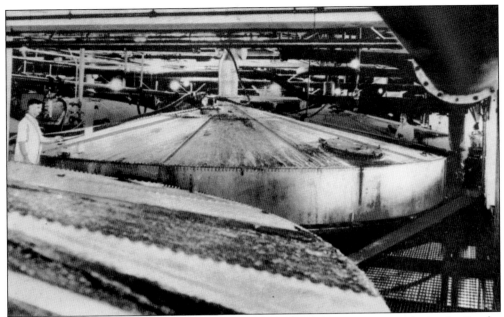

FERMENTATION VATS. Workers are seen monitoring large fermentation tanks in the Snyder Avenue distillery. After the grains had been through the mashing process, the solution spent about four days in these tanks before being sent to the distillation columns. (Courtesy of the Special Collections Research Center, Temple University Libraries.)

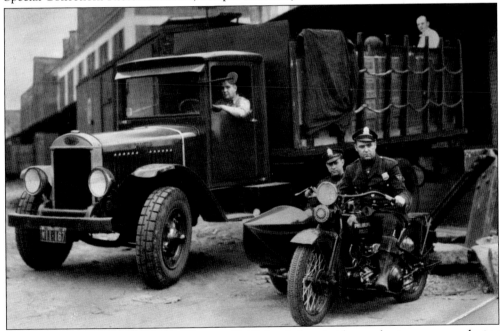

ALCOHOL SHIPMENT WITH POLICE ESCORT. Publicker Industries' largest business was producing industrial alcohols, including many solvents and antifreeze. At its height, the company was producing 60 million gallons of alcohol per year. In this scene during Prohibition, a pharmaceutical alcohol shipment leaves the plant under police protection. (Courtesy of the Special Collections Research Center, Temple University Libraries.)

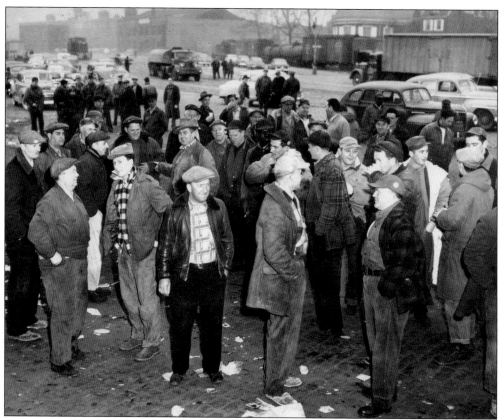

WORKERS ON DELAWARE AVENUE. This scene on the Delaware River, near Washington Avenue, exhibits the markedly different nature of the Southwark waterfront during its industrialized past. The stone-paved streets were lined with train tracks and teemed with workmen, freight trains, and trucks going back and forth. (Courtesy of Ed Kirlin.)

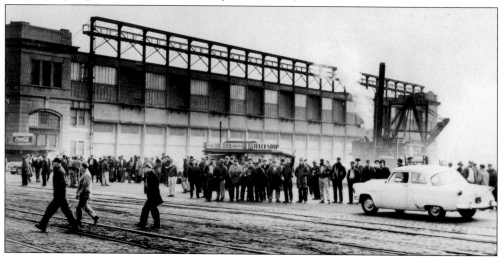

WAITING FOR THE SHIP TO COME IN. This view provides a glimpse of the waterfront as several work gangs wait for a ship to arrive. Retired longshoremen fondly describe this type of gathering as being a very social atmosphere. (Courtesy of Ed Kirlin.)

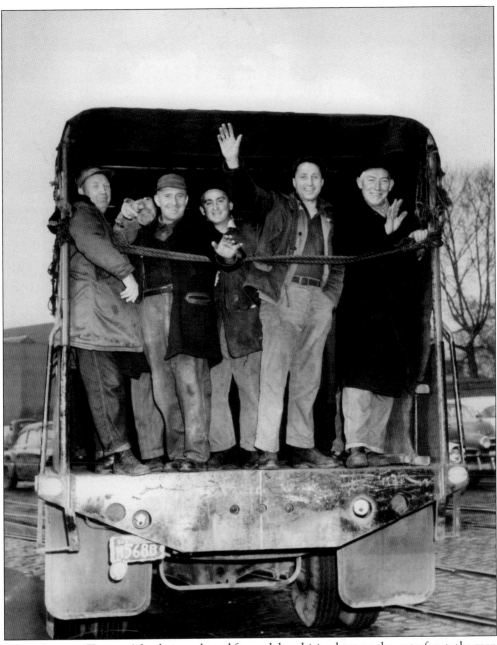

WORK CREW IN TRUCK. After being selected for work by a hiring boss on the waterfront, the men in this truck are being transported to the jobsite for a hard day's work. (Courtesy of Ed Kirlin.)

BIBLIOGRAPHY

Boonin, Harry D. *The Jewish Quarter of Philadelphia: A History and Guide, 1881–1930*. Philadelphia: Jewish Walking Tours of Philadelphia, Inc., 1999.

Boudreau, George W. *Independence: A Guide to Historic Philadelphia*. Yardley, PA: Westholme Publishing, 2012.

Dubin, Murray. *South Philadelphia: Mummers, Memories, and the Melrose Diner*. Philadelphia: Temple University Press, 1996.

Gallman, J. Matthew. *Receiving Erin's Children: Philadelphia, Liverpool, and the Irish Famine Migration, 1845–1855*. Chapel Hill: University of North Carolina Press, 2000.

Keels, Thomas H. *Forgotten Philadelphia: Lost Architecture of the Quaker City*. Philadelphia: Temple University Press, 2007.

Kyriakodis, Harry. *Philadelphia's Lost Waterfront*. Charleston, SC: The History Press, 2011.

Lynch, M. Antonia. *The Old District of Southwark in the County of Philadelphia*. Philadelphia: City History Society, 1909.

Meyers, Allen. *The Jewish Community of South Philadelphia*. Charleston, SC: Arcadia Publishing, 1998.

Miller, Frederic M., Morris J. Vogel and Allen F. Davis. *Still Philadelphia: A Photographic History, 1890–1940*. Philadelphia: Temple University Press, 1983.

Newman, Simon P. *Embodied History: The Lives of the Poor in Early Philadelphia*. Philadelphia: University of Pennsylvania Press, 2003.

Smith, Philip Chadwick Foster. *Philadelphia on the River*. Philadelphia: University of Pennsylvania Press and the Philadelphia Maritime Museum, 1986.

INDEX

DISCOVER THOUSANDS OF LOCAL HISTORY BOOKS
FEATURING MILLIONS OF VINTAGE IMAGES

Arcadia Publishing, the leading local history publisher in the United States, is committed to making history accessible and meaningful through publishing books that celebrate and preserve the heritage of America's people and places.

Find more books like this at
www.arcadiapublishing.com

Search for your hometown history, your old stomping grounds, and even your favorite sports team.